Castles and Fortifications of the West County

Andrew Powell-Thomas

AMBERLEY

For 'Team Chaos'.
It's been great fun exploring some of these sites together, but there's still
a lot more to go!

Castle
A large building, typically of the medieval period, fortified against attack with thick walls, battlements, towers, and in many cases a moat.

Fortification
A military construction designed for the defence of territory in warfare, also used to establish rule in a region during peacetime.

First published 2023

Amberley Publishing
The Hill, Stroud, Gloucestershire, GL5 4EP
www.amberley-books.com

Copyright © Andrew Powell-Thomas, 2023

The right of Andrew Powell-Thomas to be identified as the Author of this work has been asserted in accordance with the Copyrights, Designs and Patents Act 1988.

ISBN 978 1 3981 1128 8 (print)
ISBN 978 1 3981 1129 5 (ebook)

All rights reserved. No part of this book may be reprinted or reproduced or utilised in any form or by any electronic, mechanical or other means, now known or hereafter invented, including photocopying and recording, or in any information storage or retrieval system, without the permission in writing from the Publishers.

British Library Cataloguing in Publication Data.
A catalogue record for this book is available from the British Library.

Typesetting by SJmagic DESIGN SERVICES, India.
Printed in Great Britain.

Contents

Introduction

The West Country is famed for many things: rolling hills, national parks, vast swathes of farmland and some simply breathtaking coastline with glorious beaches everywhere you look. But it also has an abundance of castles and fortifications. Hundreds of them!

The first form of organised defence came thousands of years ago, with Iron Age hill forts scattered right across the region thanks to the numerous natural hills that roll across the countryside. Most are now covered by mother nature, but there are still some large earthworks to be found if you look closely. Some of these sites, however, were upgraded with wooden structures to become the first castles. Although some were built before 1066, it was the Norman Conquest of that year that left a real lasting legacy right across the landscape. These castles were designed to dominate the surrounding area, to house powerful garrisons, and were used to keep the locals in check, as well as to defend the ports and harbours from enemy attacks. Over the centuries they were modified and redesigned using stone, becoming centres of power for the rich and influential, being used to crush uprisings as well as being fought over during the English Civil War.

As the threat from overseas increased, Palmerston forts were built in the nineteenth century to protect the ports and English Channel from the advances of the French, with some existing castles upgraded for this.

The First and Second World Wars saw some new coastal batteries being constructed for the defence of the country, although most existing forts were simply upgraded and improved, and although the West Country saw a huge influx of military personnel and weaponry as the Allies prepared for D-Day in 1944, they were often stationed in temporary fortifications adjacent to existing ones.

This book aims to provide a comprehensive overview and insight into the range of castles and fortifications right across the region. It looks at their historical roles and what can be found there today – from mighty stone fortresses to derelict ruins. It is organised according to geographical location using the established counties of the West Country and alphabetical order. Fortified manor houses and 'modern' castles have been omitted.

Chapter 1

Cornwall and the Isles of Scilly

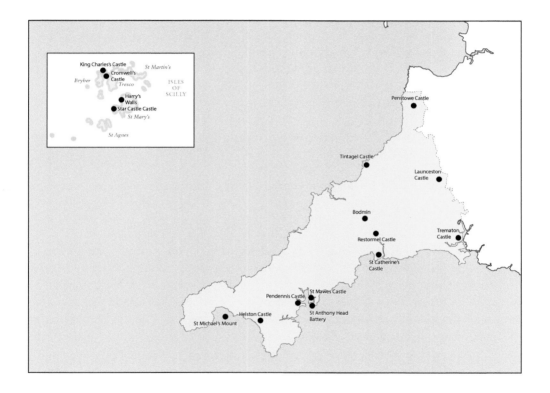

BODMIN

Bodmin is home to Cornwall's Regimental Museum, which is located at Bodmin Keep. Built in 1859, it was originally a depot for the Cornish Militia and Volunteers and in the 1880s it became the headquarters for the Duke of Cornwall's Light Infantry. By the early twentieth century, the site had grown to include living quarters, a hospital, and an officers' mess – becoming known as Victoria Barracks. During the First World War, more than 2,000 soldiers were here at any one time as the barracks was used as a training facility for new recruits before they were sent into battle. The barracks were

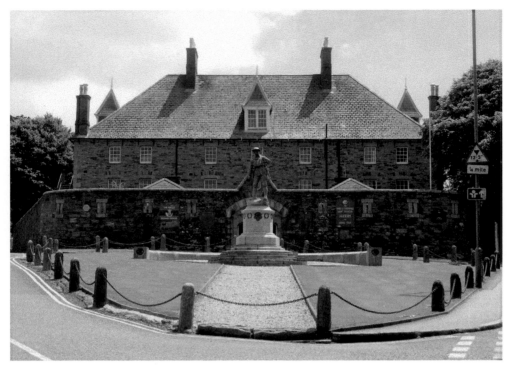

Bodmin Keep is the former headquarters of the Duke of Cornwall's Light Infantry. (Author's collection)

still in use by the regiment during the Second World War, and in May 1944 US forces moved in and occupied the site, extending it and using it for training in the run-up to D-Day. After the Second World War, a 'Foreign Language School' was established at Bodmin Barracks in 1951 as part of the nation's Cold War effort. Victoria Barracks was eventually closed as an actual operational site in 1962, leaving just the keep standing today as Cornwall's Regimental Museum.

HELSTON CASTLE

Sadly, nothing now exists of Helston Castle, which once sat at the bottom of Coinagehall Street in the town of the same name. It was built for Edmund, 2nd Earl of Cornwall and grandson of King John, in the late thirteenth century. A very wealthy man who controlled eight and a third of Cornwall's nine hundreds, he had the castle built overlooking the river valley, which at the time was actually accessible from the sea! Unfortunately, very little is known about the size and shape of the castle, with some suggesting it was just a fortified manor house. By 1478, William Worcester recorded that the castle was in ruins, and only fifty years later, John Leland recorded that there were only traces of the castle remaining.

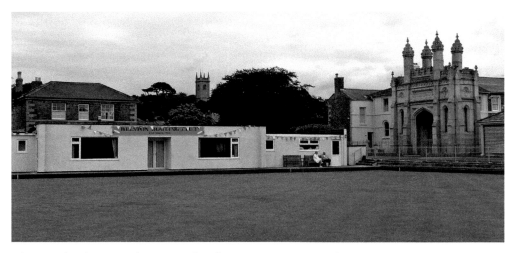

The site of Helston Castle is now a bowling green. (Courtesy of Tim Green CC BY 2.0)

ISLES OF SCILLY – CROMWELL'S CASTLE

In the aftermath of the Parliamentary invasion and capture of the Isles of Scilly in 1651 during the English Civil War, Robert Blake, General of the Parliamentarian forces, built an artillery fort on Tresco. Constructed between 1651 and 1652, and named after Oliver Cromwell, the Parliamentarian leader, it was built on the western side of the harbour to protect the deep-water channel leading to New Grimsby Harbour. This three-storey circular tower, with 4-metre-thick walls and standing at a height of

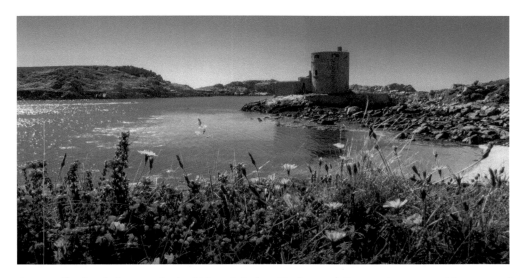

Cromwell's Castle has overlooked New Grimbsy Harbour on Tresco since 1652. (Courtesy of N. Osha CC BY-SA 2.0)

15 metres, was built on top of a small sixteenth-century blockhouse that was built as part of the nearby King Charles's Castle, which was blown up by Royalist forces prior to Blake taking the islands. Stone from these ruins was used for this new structure, which had six gun ports, providing a good range of fire between the islands of Tresco and Bryher. In 1739, a gun platform was added, and Cromwell's Castle was rearmed with 9-pounder cannons and the tower roof with 4-pounder guns. While providing protection to the harbour, the castle was never really used and soon fell into disrepair. This Grade II listed building is now looked after by English Heritage, with the roof still accessible.

ISLES OF SCILLY – HARRY'S WALLS

In 1551, construction of an artillery fort overlooking the harbour of Hugh Town was begun by the government of Edward VI to defend the island of St Mary's from a possible French attack. The plans showed a square fortification with four angular 'arrowhead' bastions in the corners, but work was slow. By 1554, only two light artillery guns were installed along with an unsuccessful attempt to create a garrison of 150 men on the island, and because of this lack of manpower, a shortage of funds and the passing of the invasion threat, the fort was never completed. Although proposals were discussed to complete the work in 1591, new defences were instead constructed at Star Castle, with only the south-west side partially constructed. This ruined south-western side of the fort remains, managed by English Heritage, with two bastions just over 2 metres high and a 27-metre-long curtain wall that is just under 2 metres high.

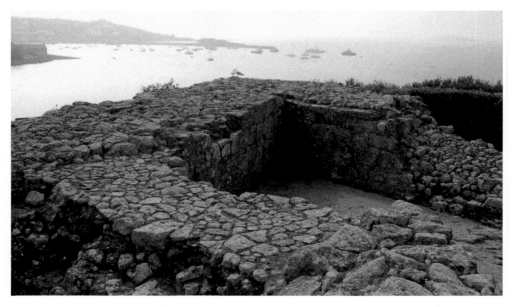

The ruins of Harry's Walls still overlook the harbour at Hugh Town. (Courtesy of Ben Smitheon CC BY-SA 2.0)

ISLES OF SCILLY – KING CHARLES'S CASTLE

In the sixteenth century, tensions with France were high, leading to war in 1538 and the coasts of England being defended with newly built artillery forts designed to defend against the longer-range cannons. This castle was built on the high ground of Castle Down to protect New Grimsby Harbour on Tresco between 1548 and 1551. Holding a battery of five guns on the western side overlooking the sea, and buildings to house a garrison, it would have aimed to prevent enemy vessels from entering the harbour. However, by 1552 all works on the Scilly Isles were halted due to a lack of funds, and it then became evident that King Charles's Castle had been built in a poor location. Standing 40 metres above sea level meant its guns could only fire at enemy ships in the harbour by being angled downwards – resulting in the cannonballs simply falling out of the muzzles! By 1554, a small blockhouse had been built just above sea level beneath the castle (later to be built upon for Cromwell's Castle) to help compensate for these issues, but building never resumed and the new 'Star Castle' was constructed on St Mary's island between 1593 and 1594, and this became the main defensive site for the Scilly Isles. During the English Civil War, Tresco was a base for Royalist privateers, and Parliamentarian Robert Blake set about invading the island in April 1651. The Royalist commander of the castle at this time, William Edgecumbe, retreated from the castle and the defenders blew up part of the site as they left, leaving the remains to the Parliamentary commander Colonel George Fleetwood. It is apparent that stonework from the now ruined King Charles's Castle was taken and reused in the construction of Cromwell's Castle by the Parliamentarians, using the blockhouse as its foundations. Since then, the ruins have remained just that, with the Grade II listed building now managed by English Heritage and open to the public.

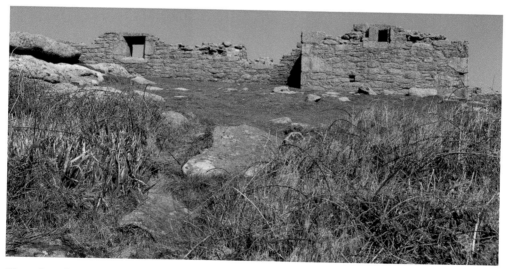

The ruins of King Charles's Castle give a tantalising idea of what it might have looked like when first built. (Courtesy of Ben Smitheon CC BY-SA 2.0)

ISLES OF SCILLY – STAR CASTLE AND THE GARRISON

Built in 1593, Star Castle was constructed following the aftermath of the Spanish Armada in 1588 and the continued threat posed to the Isles of Scilly by the Spanish fleet. With the other castles poorly located on Tresco, a new site was needed, which lead to a prominent headland jutting out on the west side of St Mary's, known as 'The Hugh', as the perfect place as it overlooked Hugh Town and its harbour. As a lookout for any intruder ships that might be heading to England, Star Castle was built in the shape of an eight-pointed star and was the focal point of this new defensive position known as the 'Garrison'. On the landward side, a curtain wall was built across the headland and contained a fortified entrance and four bastions. During the English Civil War, the Royalists on the Isles of Scilly initially surrendered to the Parliamentarians, but two years later, a revolt led to the Garrison again becoming a Royalist stronghold and a base for up to 800 men – until they were surrounded and surrendered in 1651. With an invasion by the French or Spanish still possible during the seventeenth and early eighteenth centuries, the curtain wall was extended until it surrounded the whole of the headland, with strategically placed gun batteries at regular intervals around the outer wall, allowing covering fire at all angles, from sea or land. Workshops, stores and houses were built, and with additional strengthening of the headland taking place between 1898 and 1906, the significant Steval Point, Woolpack and Steval batteries, along with the Greystones Barracks, were added to this impressive defensive position. The Garrison was used in both the First and Second World Wars due to its prominent position in the Atlantic, with over 1,000 servicemen here alone, where it was an important signal station. Today, Star Castle is a hotel, with the fortifications of the Garrison being very well preserved and managed by English Heritage, allowing visitors to walk most of the walls and explore some of the batteries.

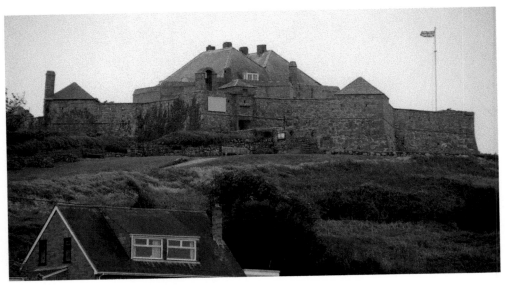

The eight-pointed Star Castle is now a hotel. (Courtesy of Ben Smitheon CC BY-SA 2.0)

LAUNCESTON CASTLE

In the aftermath of the Norman Conquest of 1066, Robert de Mortain (who was William the Conqueror's half-brother) was granted the earldom of Cornwall, and built this castle in a strategic position, controlling the area between Bodmin Moor and Dartmoor, as well as access over the Polson ford into Cornwall. Recorded in the Domesday Book, the original motte-and-bailey structure would have had wooden ramparts to begin with, and as the administrative centre for the earldom of Cornwall was a vital location. It is thought that the circular keep, stone gatehouses, towers and walls were likely to have been built in the late-twelfth century. In 1227 under Richard of Cornwall, the castle defences were improved, with the height of the keep being increased and a new great hall being built in the south-west corner. In 1272, the administrative hub of the earldom moved to Lostwithiel, as it was closer to the tin mining industries, which led to the decline of Launceston Castle. A survey in 1337 reported lots of issues with the now 'poorly maintained' fortification, and after some limited repairs a few years later, the castle became a prison. Launceston Castle was seized by the locals during the Prayer Book Rebellion of 1549, who imprisoned the Royalist leader Sir Richard Grenville inside. He died during his detention there before it was retaken by the Crown. The castle was in the possession of the Royalists when the First English Civil War broke out, until it was taken by Parliamentarian forces in 1646, and it says a lot about the condition of the castle at that time that the Parliamentarian army did not bother to slight it! In the late seventeenth century, a gaol was built in the centre of the bailey and was then used as the county jail until 1823. It is known that executions were carried out here, and it had a reputation for filthy and unhealthy conditions. A fascinating local legend has it that Queen Maria II of Portugal complained about the condition of the site to Queen

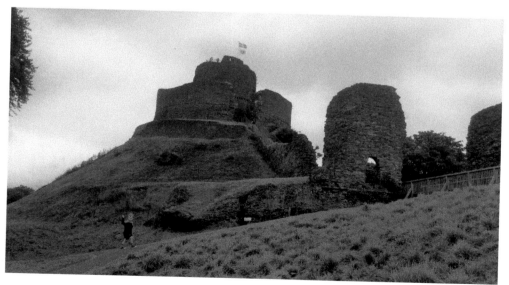

Launceston Castle. (Author's collection)

Victoria while on a visit to the area. This resulted in the gatehouse being repaired and the area being landscaping to create a public park between 1840 and 1842 by Hugh Percy, 3rd Duke of Northumberland and the castle's constable. During the Second World War, the castle grounds were used to hold a set of temporary Nissen huts as a hospital for the US Army personnel. All of this history makes it a great place to visit.

PENDENNIS CASTLE

Built by King Henry VIII in 1540 to help defend Carrick Roads (the estuary of the River Fal) against the possible invasion from France and the Holy Roman Empire, Pendennis Castle is a spectacular defensive position in Falmouth that overlooks the English Channel. Pendennis and St Mawes Castle were positioned on each side of Carrick Roads to provide overlapping fire across the water. The sixteenth-century circular keep, with its 3-metre-thick walls, was surrounded by a gun platform, and entered through a bridge and a forebuilding. This was all expanded at the end of the century to cope with an increased Spanish threat, with a ring of stone ramparts, earthworks and bastions built around the older castle. During the English Civil War, Pendennis was held by the Royalists – with Falmouth Harbour providing a vital base for Royalist supplies and a base for shipping raids. As the Parliamentarians entered Cornwall with a large army, they quickly took most Royalist strongholds, but Pendennis was different. Defended by around 1,000 soldiers under the command of Sir John Arundell, it held strong for six months. Two Parliamentary colonels led a bombardment of the castle from the land, while a flotilla of ten ships blockaded it by sea, preventing fresh supplies from arriving and ultimately forcing them to surrender in August 1646. By 1660, new fears of a foreign invasion had begun, leading to an additional gun battery being constructed, as well as a new guard barracks and classically styled gatehouse. In the 1730s, the castle was again modernised, with the interior being redesigned, the ramparts being rebuilt, and the castle's guns replaced in order to incorporate new 18-pounder cannons. In 1795, the Crown purchased the castle's land from the Killigrew family and reinforced the fortress, yet again, to deal with a fresh threat of invasion. More guns were added, the landward defences of were reinforced and a new gun position called the Half-Moon Battery was built just outside the sixteenth-century walls. The end of the Napoleonic Wars in 1815 saw the castle become neglected, before renewed fears of a French invasion in the 1850s saw better artillery installed. In 1902, the 105th Regiment Royal Garrison Artillery took over the manning of Pendennis Castle and during the First World War, the castle was reinforced by territorial soldiers as it defended the harbour, as well as being used for training purposes. Twin 6-pounder guns and longer-range artillery were installed at the beginning of the Second World War, with zig-zag trenches being dug for protection, as well as a range of new buildings being added across the site. Falmouth Fire Command, stationed in the sixteenth-century keep, had new radar-controlled, 6-inch Mark 24 guns in 1943, as the gun batteries at Pendennis were used to defend against German submarines. Decommissioned in 1956, the castle is now open to the public and is a well maintained and fascinating place, with the centuries of fortifications interweaved with each other.

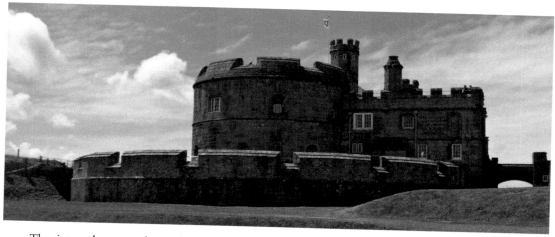

The sixteenth-century keep of Pendennis Castle still stands strong. (Courtesy of Mark AC Photos CC BY-SA 2.0)

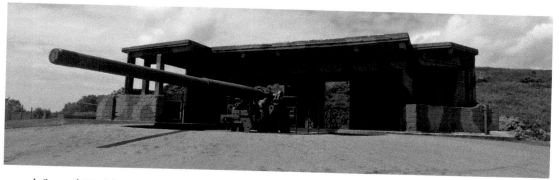

A Second World War gun still in situ in the Half-Moon Battery. (Courtesy of Mark AC Photos CC BY-SA 2.0)

PENSTOWE CASTLE

Penstowe Castle, also known as Kilkhampton Castle, was a twelfth-century castle built near the village of Kilkhampton. Positioned on a knoll with steep slopes on two sides, its oval top measures 18 metres by 8 metres, but not much else is known about this motte-and-bailey castle, and only the earthworks remain.

RESTORMEL CASTLE

Located on high ground overlooking the main crossing point over the River Fowey at the time, Restormel Castle is a well-preserved shell keep castle that was originally constructed in the aftermath of the Norman Conquest of England in 1066. Starting its

life as a traditional wooden motte-and-bailey castle for Baldwin Fitz Turstin around the year 1100, it was built in the centre of a large deer park, meaning it was probably also used as a hunting lodge as well as a fortification to keep the locals in check. When Robert de Cardinham became lord of the manor between 1192 and 1225, he developed the castle and built the stone inner curtain walls and converted the gatehouse into the stone structure that is still standing. The wall measures 38 metres in diameter and is over 2 metres thick. At a height of over 7 metres and with a ditch 15 metres wide and 4 metres deep, it would have been an impressive fortress in its heyday. Inside the walls, a kitchen, hall, living chambers and a chapel were built in a curved style to fit into the shell keep. As the castle grew in importance, so did the nearby town of Lostwithiel, and in 1264 Simon de Montfort took the castle, without bloodshed, before it was seized back a year later by Sir Ralph Arundell. Richard of Cornwall, the brother of King Henry III, was granted the castle in 1270, and when his son Edmund took over a year later, he made Restormel the main administrative base and his 'Duchy Palace'. It is said that the castle had luxurious living quarters and piped water – something very rare during this period. Edmund died in 1299, with the castle reverting to ownership by the Crown and was no longer used as a permanent residence. By 1337 it had fallen into disrepair, with the contents of the castle being stripped out and removed to other duchy residences. By the time English poet John Leland visited in the sixteenth century, the castle lay in the ruined state that can be seen today, with all timber and lead pipes taken, along with much of the stonework. Despite its dilapidated state, the castle saw its only bloodshed and military action in the seventeenth century when the ruins were occupied by Parliamentarian forces during the English Civil War. They were then attacked by a Royalist force led by Sir Richard Grenville in August 1644, and from this point the castle lay abandoned. Today, it is run by English Heritage and open to the public.

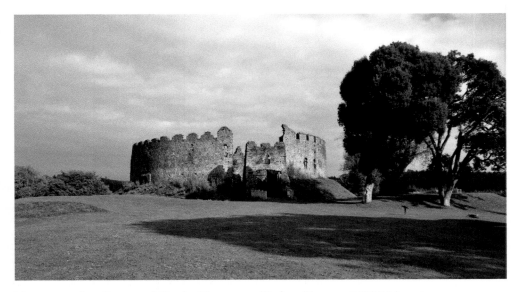

The approach to Restormel Castle. (Courtesy of Robert Pittman CC BY-SA 2.0)

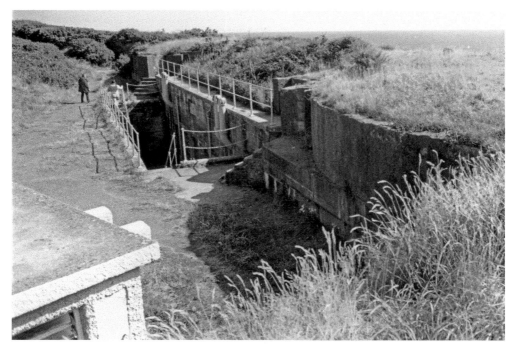

St Anthony's Head Battery. (Author's collection)

ST ANTHONY HEAD BATTERY

Built in 1895–97 to help the castles at Pendennis and St Mawes defend the estuary of the River Fal, St Anthony Head battery was installed with two BL 6-inch Mk VI naval guns, which were soon replaced with BL 6-inch Mk VII naval guns. These were in situ throughout the First World War, with the area mainly being used for army training. The Second World War saw the battery rearmed with two 6-inch VII guns and an extra two Ordnance QF 3-pounder Vickers in new positions. When the site was decommissioned in 1956, the two gun emplacements were actually infilled with rubble and earth, and it wasn't until 2012 that the eastern gun emplacement was excavated and restored by the National Trust.

ST CATHERINE'S CASTLE

Built between 1538 and 1540, St Catherine's Castle is a small two-storey D-shaped fort constructed to protect Fowey Harbour in response to the deteriorating situation between England and France and the Holy Roman Empire. Invasion seemed certain, so King Henry VIII began improving his coastal defences, and the two blockhouses positioned along the river's edge – the Fowey and Polruan blockhouses – were 'upgraded' with this new structure that was located on the headland overlooking the entrance to the estuary.

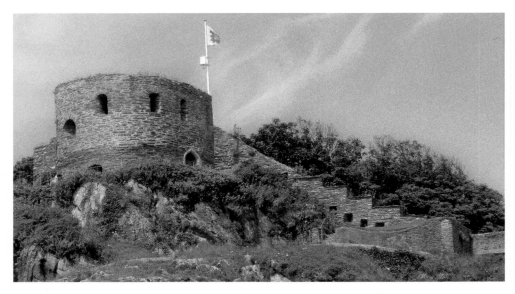

St Catherine's Castle was built to protect Fowey Harbour. (Author's collection)

Known as St Catherine's Point, the castle takes its name from this, and was equipped with five gun ports for cannons and protected with a curtain wall built over the already steep cliffs. Only measuring 5 metres by 4 metres, the ground floor had three semicircular gunports overlooking the sea and the estuary, and the first floor had two more gunports, as well as windows that could have been used for smaller weapons. Inside, there was a fireplace, chimney, and a small guard chamber by the entrance, while the curtain wall had slits for firing muskets and was surrounded by 500 square metres of castle grounds. During the English Civil War of the 1640s the site was held by the Royalists, although there is no record of any real fighting, and in the years that followed, it was maintained by the locals, and by the time of the Napoleonic Wars of 1815, it was equipped with six cannons. The castle was redeveloped in 1855 with two new gun positions being built in response to the Crimean War, and in 1887 the castle was equipped with new 64-pound muzzle-loading artillery pieces. By the turn of the twentieth century, the site was no longer used, but the Second World War saw British Southern Command rearm the site in 1940 as an observation post and gun battery. Manned initially by 364 Coast Battery of the Royal Artillery, two naval guns were installed on the existing structure and new concrete defences were built nearby. The estuary was mined and following 379 Battery of the 557 Coast Regiment being stationed here, the site was retired from active operations as the threat of German invasion receded in 1943. It is now free to visit any time of the year.

ST MAWES CASTLE

The increased tensions between England and France and the Holy Roman Empire saw King Henry VIII order five castles to be built along the important anchorage point for shipping at the mouth of the River Fal, but due to expense only two were built: Pendennis

Castle and St Mawes Castle. Their guns provided overlapping firepower across the 'Carrick Roads' waterway, and St Mawes could also cover a separate anchorage point on the eastern side of the estuary. Completed in 1542, the castle is a clover leaf shape, and was armed with nineteen pieces of artillery. The central tower is 14 metres across and 13 metres high, with over 2-metre-thick walls, and a range of rooms including a kitchen, storeroom and officer's quarters. This central tower is linked to the forward and side bastions, each of which forms a gun platform, with embrasures for larger artillery pieces. A small permanent garrison stayed at the castle, with local militia providing additional support in times of need. War with the Spanish broke out in 1569, and the garrison was strengthened to 100. An additional gun battery was built, and as a result of the failed Spanish Armada of 1597, two earth and timber bastions were built out from the original stone castle to hold guns – and eventually became the main batteries for the castle. As the threat subsided, in 1623 the castle had a much smaller garrison of sixteen men. In 1642, the English Civil War broke out, and Pendennis and St Mawes castles were important in defending the supply routes to the Continent, and, of course, Carrick Roads was still an important place for anchoring the royal fleet. As large numbers of Parliamentarian troops approached, the soldiers at St Mawes quickly surrendered without putting up any resistance – due to war-weariness, being outnumbered, the generous terms of surrender and possibly because it is overlooked by higher ground at the back! The artillery and guns were then taken and used to assist with the siege of Pendennis Castle. The castle continued to operate with Pendennis Castle as a defensive base in the eighteenth and nineteenth centuries. The defence of Falmouth was critical during the wars with France and from 1775 until 1780 the local militia was called up

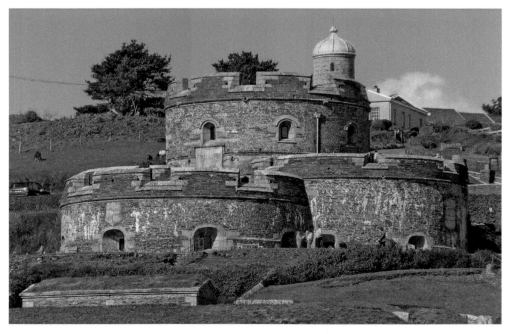

The clover-shaped sixteenth-century keep of St Mawes Castle. (Courtesy of Tim Green CC BY 2.0)

to help defend St Mawes, which by now had over thirty pieces of heavy artillery! In 1805 St Mawes was armed with ten 24-pounder guns and in 1850, with fears yet again of a French invasion, the castle went through a complete overhaul, in order to defend against the newer iron-made warships. A new 'Grand Sea Battery' was built beneath the castle, equipped with eight 56-pound and four 64-pounder guns. The older part of the castle was used as a barracks, but seeing as it had limited space, it was generally used as a training base. At the start of the twentieth century, it was decided that Pendennis Castle, and the newly built St Anthony's battery, could defend the area from attack, so St Mawes lost its military importance and was disarmed. During the First World War, the castle was used as a barracks for the nearby St Anthony's battery. In 1939, at the start of the Second World War, the British Army took control of the site, with 173 Coast Battery taking over in 1941 with a new, twin 6-pounder battery, a Bofors anti-aircraft gun and searchlights at the base of the Grand Sea Magazine. Although removed from active service in 1945, the gun battery was still used as a training facility until 1956, and by 1970 much of the Victorian concrete defences were cleared from the Grand Sea Battery, and the 1941 battery was completely destroyed. Today, it is a well-maintained attraction that gives you some excellent glimpses into its history.

ST MICHAEL'S MOUNT

The site of St Michael's Mount began as a monastery in the eighth century. In 1193, Sir Henry de la Pomeroy captured the Mount, and the 57-acre site had a number of buildings constructed including a castle. In September 1473 the 13th Earl of Oxford, John de Vere, took over the island and held it during a staggering twenty-three-week siege against 6,000 of King Edward IV's troops, eventually surrendering in February 1474. Just

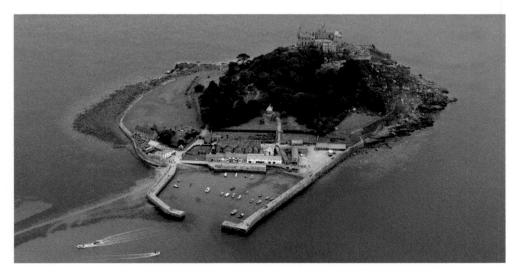

A stunning aerial view of St Michael's Mount. (Courtesy of John Fielding CC BY 2.0)

over twenty years later in 1497, Perkin Warbeck (pretender to the English throne) briefly occupied the Mount just a few months after the Cornish Rebellion of the same year, and in 1549 Sir Humphrey Arundell, Governor of St Michael's Mount, led the Prayer Book Rebellion from here. During the English Civil War, Sir Arthur Bassett held St Michael's Mount for the Royalists against the Parliamentarian forces, until they finally captured it in July 1646. Life on the Mount calmed down significantly after this, with the notable exception of pillboxes being built on the island during the Second World War in 1940.

TINTAGEL CASTLE

Located on the peninsula of Tintagel, the atmospheric ruins of Tintagel Castle give us a glimpse of what would have been a visually stunning fortification. It is thought the site was probably originally occupied by the Romans, but the first recorded structure built here was a castle constructed by Richard, 1st Earl of Cornwall, in 1233. It is said that the castle was likely built in a more old-fashioned style for the time to make it appear more ancient – in order to establish a connection with the ancient Arthurian legends. In the years that followed, the Earls of Cornwall lost interest in the castle – possibly due to its difficult position to access – leaving parts of the structure to be used as a prison and the land being used as pasture. In the 1330s the roof of the Great Hall was removed, and with significant erosion of the isthmus (the narrow piece of land connecting the peninsula to the mainland) the castle became more and more ruinous.

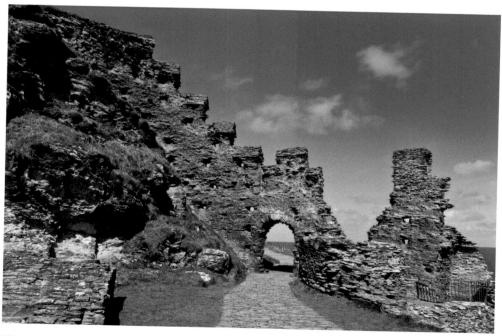

The castle walls of Tintagel Castle. (Courtesy of Ben Smitheon CC BY-SA 2.0)

When England was threatened with invasion from Spain in the 1580s, the defences of the site were strengthened at the Iron Gate – although the castle served little strategic importance given its condition. In the Victorian era, the fascination with the Arthurian legends led to the ruins becoming the tourist destination they are to this day.

TREMATON CASTLE

Robert, Count of Mortain, built the original castle here in the years immediately after the Norman Conquest – with the wooden motte-and-bailey structure being listed in the Domesday Book of 1086. Overlooking Plymouth Sound, the castle was strategically placed to ensure that access for the ferry from Saltash Passage to Plymouth – the only means to cross the River Tamar at this time - was maintained. The castle belonged to the Valletort family, who owned the castle (and the rights to the ferry crossing) until 1270. During this time the wooden structure was replaced with stone. The oval keep reached to around 10 metres high, with its walls 3 metres thick, while a two-storey rectangular gatehouse and portcullis were constructed in the thirteenth century, both of which are still standing and in good condition. The stone Norman walls are still evident on the site, although these are in a more ruined state. Since 1270, Trematon has been the property of the Earls and Dukes of Cornwall, becoming less important as a military stronghold as the centuries progressed and more of a status of power. It is interesting to note that when Sir Francis Drake returned to Plymouth from his circumnavigation of the globe in 1580 – the first Englishman to do so – Trematon Castle was used to store the gold, silver and precious stones he had pirated from the Spanish along the way, before they were taken to Queen Elizabeth I. Clearly the castle and its walls were still completely intact at this point. In 1808, a six-bedroom Georgian house was built in the castle courtyard, demolishing part of the original castle wall to give better views of the countryside.

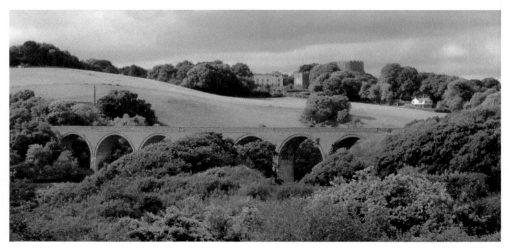

A view of Trematon Castle overlooking the Forder Viaduct in Saltash. (Author's collection)

Chapter 2

Palmerston Forts of Plymouth

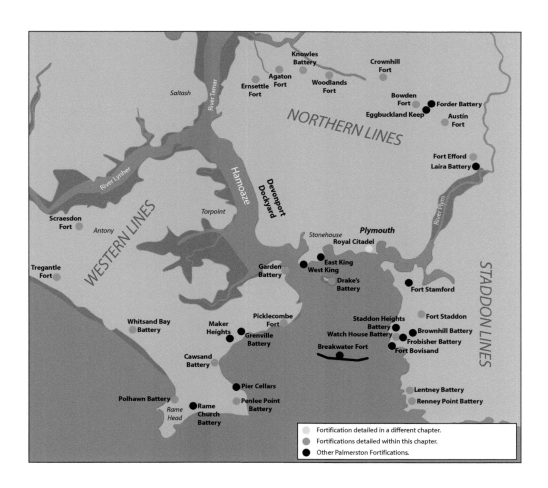

In 1859 a royal commission investigated Britain's military readiness to counter a possible foreign invasion. Consisting of six members of the Armed Forces, along with a representative from HM Treasury, the commission published their findings in February 1860 concluding that Britain's military forces were insufficient to guarantee an invasion

attempt would fail. They recommended vital facilities across the coast – including the Royal dockyards at Chatham, Devonport, Portland, Portsmouth and Milford Haven – should be protected by rings of forts. The proposals were implemented by the government of Lord Palmerston and represented the biggest peacetime military infrastructure project in British history. These forts built around Plymouth were intended to ensure an enemy force was unable to close within artillery range of the vitally important Royal Navy dockyard in Devonport, and there were five defensive lines: the Northern Lines, Staddon Lines, Western Lines (on the Cornish side of the River Tamar), Outer Sea Defences and Inner Sea Defences.

The first three were focused on landward defence ensuring an enemy force did not circumvent the sea defences by moving inland around them in order to attack the dockyard from the rear. The sea defences were focused on denying an enemy access into Plymouth Sound with the Outer Lines barring access through the breakwater and the Inner Defences denying access into the Hamoaze and River Tamar. Collectively the land and sea defences completely enclosed Plymouth Sound and the high ground surrounding the entire area, thus ensuring the safety of the dockyard. Additional fortifications and improvements were then added in the 1880s and 1890s. Many of the Palmerston forts retained an active military role until the mid-1950s. Crownhill Fort continued in that role until the 1980s while others, Fort Staddon, Scraesdon Fort and Tregantle Fort continue to be in use by the Ministry of Defence.

WESTERN LINES

Rame Head

A number of the Western Lines forts are located on the Rame Peninsula. At Penlee Point, Penlee Battery was constructed around 1890 as part of the defensive ring around Plymouth. It was armed with two 6-inch BL guns and a 13.5-inch BL and remained in operation during the First and Second World Wars. The battery was disarmed in 1956, and during the 1970s, the majority of the site was demolished, with the gun positions being filled in, and Penlee Battery is now a nature reserve. Another site here is Polhawn Battery. Built in 1864, the two-storey structure overlooks the bay, with the upper floor consisting of seven casemates, which housed 68-pounder guns, while the lower floor made up the accommodation and a magazine. During the First World War, the battery was used for accommodation for gunnery officers and the magazine was used as a military detention cell. Sold by the War Office in 1927, it became a hotel and tearoom, changing its name to Polhawn Fort in the process, and today it is a hotel and wedding venue.

Scraesdon Fort

Designed in 1859, the impressive Scraesdon Fort is near the village of Antony and overlooks the River Lynher. It was designed to have an impressive twenty-seven 7-inch breech-loading guns on the ramparts, surrounded by a dry ditch, and between 1893 and 1903 a military railway connected the fort with the River Lynher at Wacker Quay, near St Germans. Scraesdon was later used by the MOD as a training barracks. Now a Grade II listed building, it is generally empty and derelict, although it is still sometimes used by Royal Marine Commandos or local Army Reserve units.

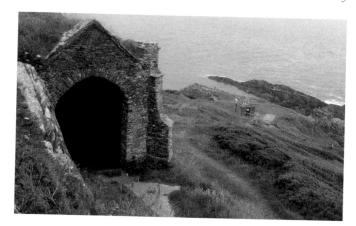

The view from Penlee Battery. (Courtesy of Ben Smitheon CC BY-SA 2.0)

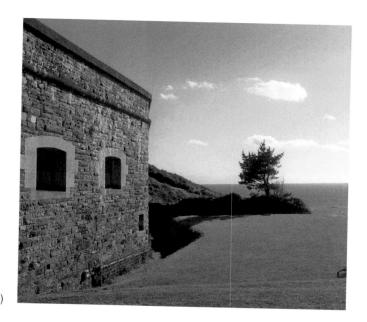

Polhawn Fort. (Courtesy of Ben Smitheon CC BY-SA 2.0)

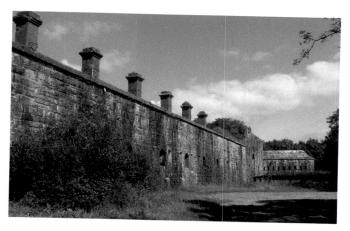

The east wall of Scraesdon Fort. (Courtesy of Ben Smitheon CC BY-SA 2.0)

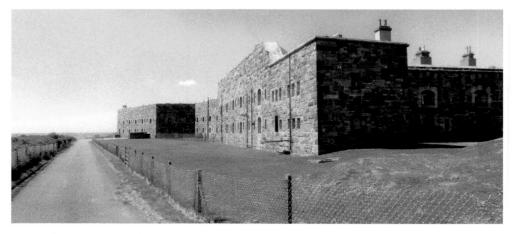

Tregantle Fort was built between 1859 and 1865. (Courtesy of Ben Smitheon CC BY-SA 2.0)

Tregantle Fort

Built in 1865, Tregantle Fort was the major fortification of the Western Lines. It was designed to hold thirty-five large guns and had barrack accommodation for a staggering 2,000 men. By the 1900s it became an infantry battalion headquarters, with fourteen officers and 423 other ranks and was used for rifle training. Garrisoned during the First World War, it then lay empty until 1938, when it was used as the Territorial Army Passive Air Defence School, before being used as the Army Gas School at the start of the Second World War, and from 1942 as US Army accommodation in the build up to D-Day. Since then, the fort has remained part of the Defence Estate and is still used for Royal Marine training, with many of the rifle ranges located here sloping steeply down towards the sea.

Whitsand Bay Battery

Work started on Whitsand Bay Battery in 1889 and took just over five years to complete, ensuring there was a defensive position between Tregantle Fort and Rame

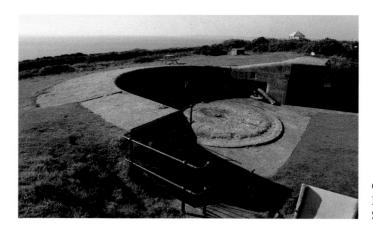

Gun positions at Whitsand Bay. (Courtesy of Ben Smitheon CC BY-SA 2.0)

Head. A battery of three 12.5-inch rifled muzzle-loaders and two 6-inch breech-loaders was constructed near Stone Farm at the top of Tregonhawke Cliff, and to protect from land attack, it was surrounded by a ditch and three machine-gun caponiers along with accommodation for forty men. Although garrisoned during the First World War, it was disarmed in 1920, and during the Second World War was used for radar training, as part of the Coast Artillery Training Centre, Plymouth. Today, Whitsand Battery is open to the public as a caravan park and many of the original features can still be seen – although the ditch has been filled in.

NORTHERN LINES

Agaton Fort

Agaton Fort was built between 1863 and 1870 to the north-west of the city, with clear views over Tamerton Lake. Part of the Northern Lines of defence, it had a surrounding ditch and twenty guns – or at least that was the plan. By 1893, there were just eight guns in place and as the need for the fort diminished, it was disarmed by the turn of the twentieth century. It was used as a military depot during the First and Second World Wars, before being sold in 1958.

Austin Fort

Overlooking the Forder Valley, Austin Fort was built to protect the north-east of the city. Designed to accommodate sixty troops, it was surrounded by a dry ditch that linked up to the front ditches of Forder Battery and Bowden Fort – protected by a two-storey guardhouse. Like other forts built in the area, the need for the fort faded as it was being built and it was never fully armed as intended. Austin Fort was used by the

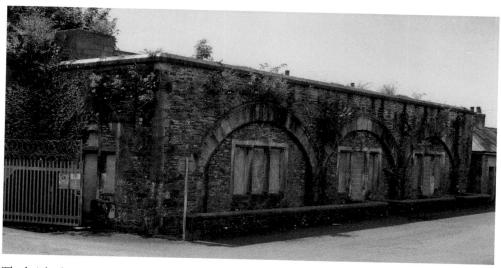

The bricked-up remains of Agaton Fort. (Author's collection)

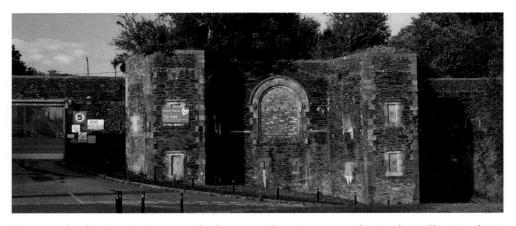

The now derelict Austin Fort once had commanding views over the Forder Valley. (Author's collection)

Devon and Cornwall Auxiliary Unit during the Second World War and is now owned by Plymouth City Council.

Bowden Fort

Bowden Fort occupied the lower ground to the east of the more important Crownhill Fort and was built with the intention of providing additional cover for it. There was only accommodation for sixteen men, due to the close proximity of other barracks nearby, and it was equipped with seven 7-inch rifled breach-loading guns and a defensive ditch. Used sparingly, it was a military depot during the First and Second World Wars and it is now the site of a garden centre.

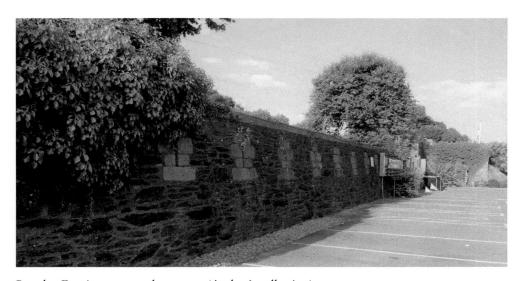

Bowden Fort is now a garden centre. (Author's collection)

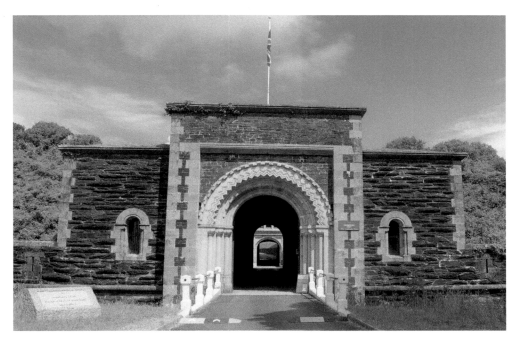

The gatehouse entrance to Crownhill Fort. (Author's Collection)

Crownhill Fort

As the focal point of the Northern Lines of defence, Crownhill Fort was, unusually for its time, positioned in an exposed position so its formidable firepower could dominate the area. With thirty-two guns, six of which were enclosed in casemates, mortars and a ditch, Crownhill was fully armed with its complete compliment of weapons right into the late nineteenth century. During the First World War it was used a transit depot for soldiers en route to the Mediterranean and then became home to the Second Battalion of the Royal Devonshire Regiment. The Second World War saw anti-aircraft guns installed here as the existing facilities made this an ideal location. After the war, Crownhill became the Headquarters of the Commando Support Squadron, Royal Engineers, and they provided logistical support during the 1982 Falkland's War. Decommissioned in 1985, it was purchased by the Landmark Trust and remains in excellent condition today.

Efford Fort

Built on a hill overlooking a bend in the River Plym and forming part of the Northern Line defences of the city, Fort Efford had eleven 7-inch guns (which became sixteen in 1893) and accommodation for over 100 troops. It is now owned by Plymouth City Council.

Ernesettle Battery

Ernesettle Battery, the furthest west of the Northern Lines of defence, covered the all-important Tamar valley. There were barracks for sixty men, six motor positions and

The entrance to
Ernesettle Battery is all
that can be seen today.
(Author's collection)

facilities for fifteen guns, although like most of the installations built around Plymouth at the time, Ernesettle Battery never became fully armed as intended. Disarmed before 1900, it remained in military ownership and was used as an anti-aircraft observation post during the Second World War. The site remains part of the Ernesettle Royal Navy armament depot.

Knowles Battery

Although the ground in front of Knowles Battery was covered by the Woodlands and Agaton Forts, Knowles Battery was constructed in 1869 to help provide additional defence. It had a ditch, thirteen gun positions and a two-storey guardhouse, which had the main magazine located underneath it. By the early 1900s the fort had become obsolete, but it was used during the Second World War as a barrage balloon site. After the war a school was built on the site and the now Grade II listed Knowles Battery is now part of Knowle Primary School.

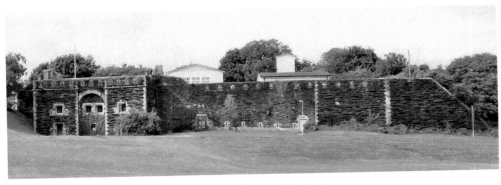

Knowles Battery with the school behind. (Author's collection)

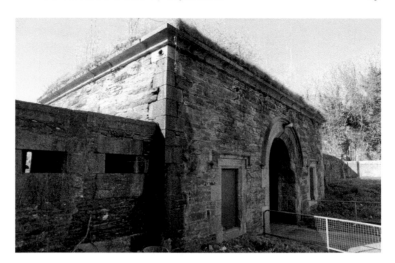

The entrance to
Woodlands Fort.
(Author's collection)

Woodlands Fort

Woodlands Fort occupies a ridge of high ground over the Budcreek Valley. Construction lasted seven years from 1863 to 1870, and it was surrounded, like most forts at this time, by a ditch. A two-storey barrack block provided room for around 100 soldiers and it was designed to hold eighteen large guns. However, by 1885 the fort had received only eight 7-inch rifled breach-loading guns and was disarmed by 1900. It was used as a barracks in the First World War and used again in the Second World War – mainly for storage.

STADDON (EASTERN) LINES

Lentney and Renney Point Battery

Not constructed as part of the 1859 royal commission, Lentney Battery and Renney Point Battery were two forts built between 1905 and 1906 to provide additional protection to the eastern side of Plymouth Sound. Designed to compliment each other, Lentney contained short range weaponry while Renney had longer range guns capable of hitting armoured battleships. Both were used during the First and Second World Wars, with the guns at Renney able to reach 20 miles out to sea, as well as having anti-aircraft and mortar capabilities. Lentney Battery was decommissioned in 1956 while Renney Point Battery was disarmed in 1957 but used for training purposes right up until 1991. Today, both stand overlooking Plymouth Sound as they have done for the last 100 years.

Staddon Fort

Dominating the eastern side of Plymouth Sound, Staddon Heights stand over 120 metres above sea level and offers clear views across the city and beyond to the Royal Navy dockyard at Devonport. With developments in artillery the Heights became strategically important as an enemy occupying them could bombard the dockyard

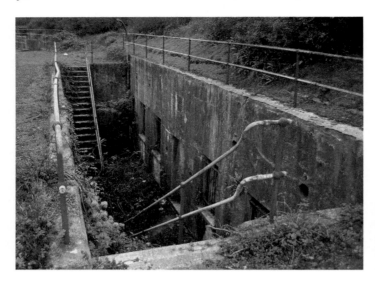

Entry to the magazines and barracks at Lentney and Renney Point Battery is still possible. (Author's collection)

and Plymouth Sound, resulting in Staddon Fort being built between 1861 and 1869. Originally intended to consist of twenty-five 7-inch rifled breach-loading guns, two 64-pounder guns, four 8-inch Howitzers facing east and a keep, concerns over costs and the increasing developments in artillery meant that this never happened. Instead, the fort was divided into an inner and outer section, along with a deep ditch, and the weapons installed were scaled back to just two 5-inch breach-loading guns, four 64-pounder guns, six 7-inch rifled breach-loading guns and eight 32-pounder guns. Although disarmed before the First World War, the prominent position of the fort has meant it continued to have a military use, including hosting RAF escape and evasion training. Currently in use as a Royal Navy communications site, it has two large radio masts visible from outside.

Watch House Battery

Watch House Battery was a smaller fort constructed in the nineteenth century with five-gun emplacements. In 1901 the battery was reconstructed and in the First World War the battery was manned by the Devonshire Royal Garrison Artillery. After being manned in the Second World War the battery was decommissioned in 1956.

OUTER SEA DEFENCES

Cawsand Fort

Cawsand is such an idyllic place to visit now, but it is amazing to think that in 1779 a sixty-six-strong Franco-Spanish fleet anchored in Cawsand Bay with the intention of landing 30,000 soldiers. Their aim was to seize the high ground overlooking Plymouth and bombard it. Thankfully, a storm put paid to their ideas, and with that Cawsand was fortified. Pemberknowse Fort was constructed at Cawsand beach and as part of Lord Palmerston's commission, it was redeveloped so that there were nine guns facing

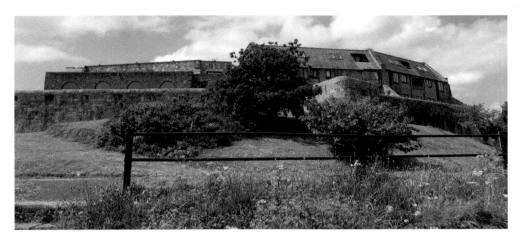

Cawsand Fort – now housing. (Author's collection)

seaward (covering the whole of Cawsand Bay itself) and a further fourteen guns to protect the fort from a landward attack. The fort was garrisoned well into the early part of the twentieth century, including the First World War, but was later released by the military in 1926 and has since been converted into housing.

Picklecombe Fort
Picklecombe Fort was part of the western defence for Plymouth Sound. Built near an earlier earthwork battery dating to the start of the nineteenth century, it was constructed between 1864 and 1871 and armed with forty-two 9-inch and 10-inch

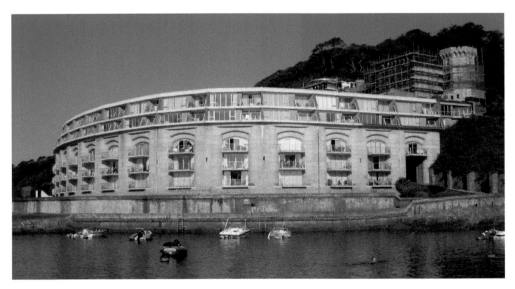

Fort Picklecombe is now residential apartments. (Courtesy of Simon James CC BY-SA 2.0)

muzzle-loading guns, which were positioned in a huge semicircular arc of two-storey casemates. Rearmed in the 1890s, the fort was never used in anger, and its guns were removed in the 1920s. However, the Second World War saw the 566th Devon Coast Regiment, Royal Artillery, take control of the fort and two 6-inch guns and two twin 6-pounder guns were installed, along with the fort range finder and searchlight positions to the west. Decommissioned after the war, it stood derelict for years, before being converted into residential apartments. Just behind it, the rather imposing 'Officers' Mess' building stands overlooking the main fort complex, and these too have been turned into flats.

INNER SEA DEFENCES

Drake's Island Battery

The ongoing war with France in the mid-sixteenth century saw a garrison stationed at Drake's Island in 1551 with a stone and turf wall being constructed for its defence. By the 1590s, as war with Spain was on the horizon, the fortifications were strengthened, with over guns being installed along with an increased garrison of 100. In the aftermath of the English Civil War, notable Parliamentary prisoners were held here, and in the late eighteenth century new magazines were built along with other small improvements. In the mid-nineteenth century, large casemates were constructed on the island along with improved accommodation for those working there. During the 1860s, 9- and 10-inch RML guns were used and these were upgraded to 11 and 12 inch by the 1880s along with a Brennan Torpedo launcher. In total, there were twenty-one guns in armoured casemates, ensuring the whole island was effectively fortified. During the Second World War, a twin 6-pounder gun was installed, and Drake's Island was garrisoned by around 500 soldiers who supported coastal defence and anti-air operations.

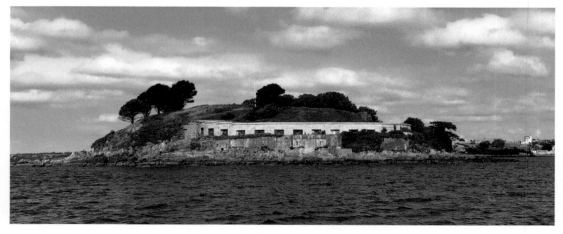

Drake's Island – located in a perfect position right in the middle of Plymouth Harbour. (Author's collection)

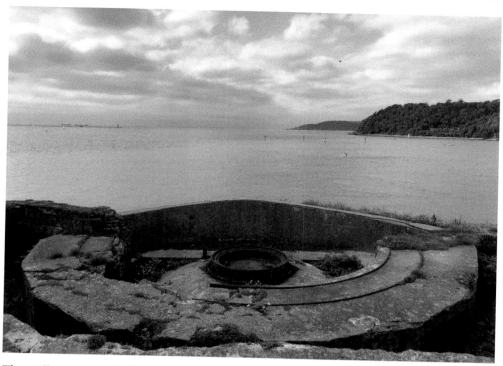

The artillery on the island has an uninhibited range of fire. (Author's collection)

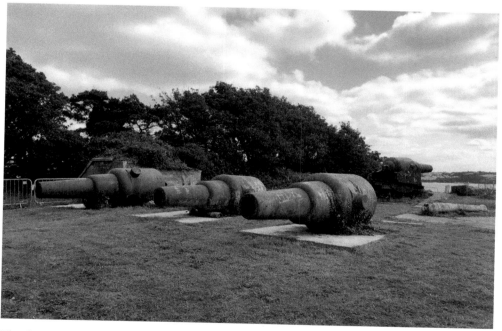

The sheer size of the weapons is staggering. (Author's collection)

A maze of tunnels zig-zag across the island. (Author's collection)

Garden Battery at Mount Edgcumbe

A single-storey artillery blockhouse was the first of the defences on the shores of Mount Edgcumbe and was built during the Tudor period in 1547, protecting the mouth of the River Tamar, and was added to during the First English Civil War when it was occupied by Royalist forces. After the royal commission of 1859, work began on developing and improving the Garden Battery in 1862. Designed to work with Drake's Island Battery and protect the main deep-water channel, a new curved structure held seven 9-inch rifled muzzle-loading guns enclosed in iron-plated casemates. By 1870, the Defence Committee deemed the Garden Battery to be of little use as it was located behind the main outer defensive line, and so it was disarmed. However, in 1891 it was rearmed with guns and by 1899 four 12-pounder quick-firing guns had been fitted along with two machine guns. It remained armed during the First World War, and although it was decommissioned in 1927, the Second World War saw it reactivated and rearmed. Mount Edgcumbe House itself was destroyed by German bombers during the 1941 Blitz on Plymouth, and although rebuilt since, a small part of that derelict building still stands in the garden as a reminder. US troops were stationed at Mount Edgcumbe Country Park during the Second World War and left from Barn Pool Beach, heading for the horrors that lay in wait on Omaha Beach during the D-Day landings.

The Tudor-built Blockhouse at Mount Edgcumbe. (Author's collection)

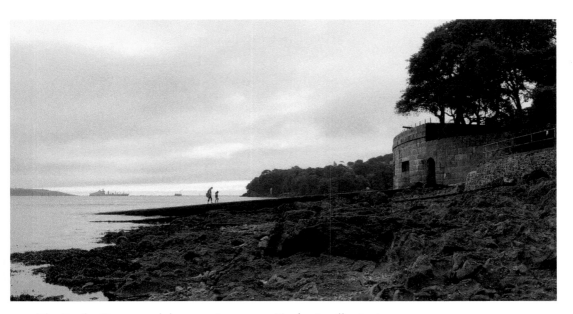

The Garden Battery and the water it protects. (Author's collection)

Chapter 3

Devon

BAMPTON CASTLE

A defensive mound was originally built in Saxon times and in the aftermath of the Norman Conquest, the Normans built a motte-and-bailey wooden castle overlooking the River Batham in around 1067 to consolidate their newly found power in the region. The feudal barony of Bampton had its head here but in 1136 there was a dispute with King Stephen about the ownership of lands around Uffculme, who besieged the castle, forcing it to surrender. Later, the new lord of the manor, Richard Cogan, obtained a royal licence to crenelate it and a stone mansion was built on the motte. By the seventeenth century the mansion and walls were crumbling down, so much so that when the English Civil War reached the area in 1645, Royalists from Tiverton Castle burnt down the town of Bampton without the castle being given a second thought. All the stonework has been removed since then, leaving just the motte on the outskirts of the village.

BARNSTAPLE

Following the Norman invasion of 1066, the Bishop of Coutances, Geoffrey de Mowbray, built a wooden castle in the centre of the town due to its prominent river crossings. As the town was fortified, the castle was soon redeveloped in stone, but less than 200 years after it was originally built, the need for a defensive position in Barnstaple declined and the castle's fortunes waned. By 1326 the castle was nothing more than a ruin and the great stones once used for its walls were reused in other buildings around the town, leaving just the tree-covered motte today. During the English Civil War, Barnstaple was besieged by Royalist troops on 12 September 1644 and held out for just under a week before being taken on 17 September.

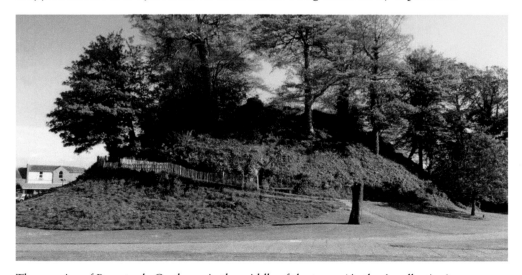

The remains of Barnstaple Castle are in the middle of the town. (Author's collection)

BAYARD'S COVE FORT

Bayard's Cove Fort was constructed sometime in the sixteenth century to protect the harbour of the coastal town of Dartmouth, which was an important trading and fishing port. There is no precise date, with some historians suggesting it was built at the start of King Henry VIII's reign in 1510 or later on in 1529. We do know that it was complete by 1537 and was constructed in response to the fears of a French or Spanish attack on the town. These fears had grown over the last hundred years or so, which had led to the town developing Dartmouth Castle into an artillery fort after 1486 and building Kingswear Castle in 1491. By the time of the English Civil War in 1642, Dartmouth was a Parliamentarian town. This led Prince Maurice to lay siege to it before taking it for the Royalists relatively easily, as the towns defences all faced the sea and were vulnerable to a land attack. In January 1646, Sir Thomas Fairfax led a Parliamentary army to retake Dartmouth and seized Bayard's Cove Fort and the five iron artillery guns stationed there. By 1662, the fortifications in Dartmouth were garrisoned by a royal force of twenty-three men but it gradually fell into decline – being mainly used for storage. In the Second World War it was used as a machine gun post by the Home Guard, and the shell of this building is now free to visit, protected by English Heritage.

Bayard's Cove Fort as seen from across the River Dart. (Author's collection)

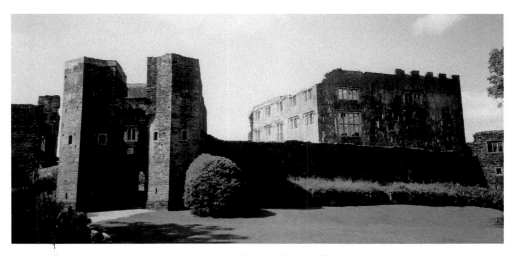

The picturesque ruins of Berry Pomeroy Castle. (Author's collection)

BERRY POMEROY CASTLE

The powerful Norman de la Pomeroy family was given the feudal barony of Berry Pomeroy just after the Norman Conquest of England in 1066 and although they developed a deer park here in 1207, the first reference to a castle does not appear until 1496, with most historians agreeing that the castle was probably built around this date, in the late fifteenth century. The castle is located within the boundaries of the deer park and consisted of a dry moat, which is now mostly filled in, a splendid gatehouse that grabs your attention the first time you see it and ramparts enclosed by the curtain wall. The castle was bought by the Seymour family, who lived here in style until the Civil War when the castle was raided by Parliamentarians and the head of the family, Sir Edward Seymour, was imprisoned in London. By 1710 the castle had been stripped of all its useful materials, leaving the shell of this 'romantic ruin' that we see today.

BICKLEIGH CASTLE

Bickleigh Castle was a Norman motte-and-bailey castle built in the eleventh century and given by King William to Sir Richard de Redvers. In the fifteenth century the powerful Courtenay family built a stone mansion on the site and also incorporated some of the earlier buildings, such as the chapel, into their designs for the land. During the English Civil War of the seventeenth century, Charles I's queen, Henrietta Maria, stayed in the castle as a guest of Sir Henry and Lady Dorothy Carew in 1644, on her way to Exeter. As a result of this, at the end of 1645, Fairfax's Parliamentarian troops attacked the castle for its strong Royalist links and a lot of the buildings and structures were slighted beyond repair and demolished. In the aftermath, the Carew family salvaged what they could, turning Bickleigh into the fortified manor house that you see today.

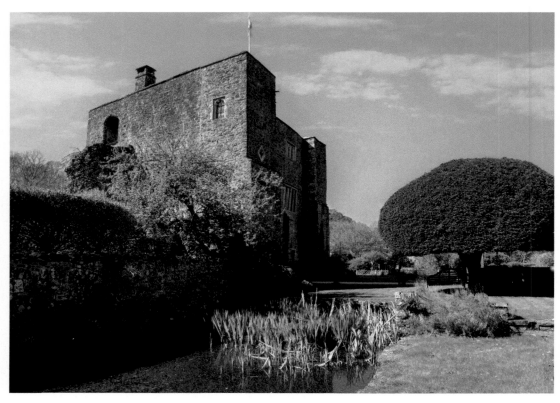

The fortified manor house at Bickleigh as it stands today. (Courtesy of Alison Day CC BY-ND 2.0)

BRIXHAM

In 1586, a small battery was constructed at Brixham, defending the town from the threat posed by the Spanish, and during the American Civil War of Independence towards the later part of the eighteenth century, additional gun emplacements were installed at what is now 'Battery Gardens' as Brixham was an important port for the Navy. This expanded site of 14 acres saw 24-pounder guns arrive in May 1780, and the fort was used during the French wars, being manned by the 11th Devon Artillery Volunteers, Royal Garrison Artillery. The battery was used for gunnery training during the 1870s and was used as a coastal lookout during the First World War. The Second World War saw Brixham battery receive additional weaponry to that of the existing 4.7-inch (120-mm) guns emplacements – with anti-aircraft defences and a 6 pounder Hotchkiss harbour defence gun brought in. The site was manned by different regiments from the Royal Artillery while being strongly supported by local men transferred from 'D' Company (10th Torbay) Battalion, Devonshire Home Guard. A number of structures still remain, such as the observation post, gun floors and searchlights, and Brixham Battery Heritage Centre ensures that these important relics are preserved.

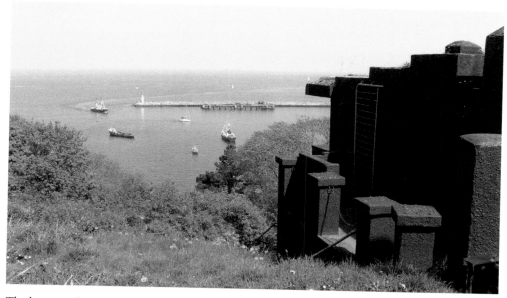

The battery observation post at Brixham still has a commanding view towards the breakwater. (Courtesy of Warwick Conway CC BY-SA 2.0)

COLCOMBE CASTLE

The village of Colyton once had a stone castle, a house which was later fortified, modified and rebuilt numerous times, but little else is known of it today. In 1644, during the English Civil War, it was the headquarters for the Royalist troops, who used it as a base for their attack on Stedcombe, but it then fell into Parliamentarian hands and was almost completely destroyed. Today, very little remains, aside from one ancient building in the yard of Colcombe Abbey Farm.

A Tudor arch from a window with heraldic shields at each side, formerly part of Colcombe Castle, now set into the footbridge over a leat.

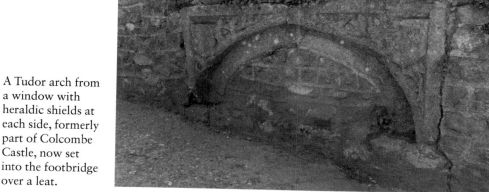

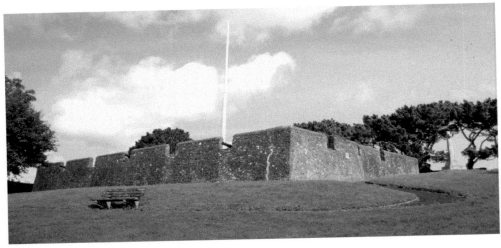

A view of Chudleigh Fort, now a public park. (Author's collection)

CHUDLEIGH FORT, BIDEFORD

Around 1642, important Devon landowner James Chudleigh built a pair of earthwork artillery forts, each containing eight guns, to guard Bideford. These forts were placed on the high ground, overlooking both sides of the River Torridge and prevented Royalist ships from using the river. One of these was named Chudleigh Fort. The Royalist armies saw many successes in the south-west in 1643 and as a result, the Parliamentarians withdrew into the two small fortresses in Bideford and were besieged. Fierce fighting erupted, which eventually saw the Royalist forces storm the forts and the town of Bideford fall. Following the Civil War, the site lay empty, only being rebuilt in the nineteenth century by James Ley, who gave it fourteen gun emplacements instead of the eight the original fort had. The site was later purchased by public subscription in 1921 for use as a public park in memory of those who died in the First World War.

DARTMOUTH CASTLE

Dartmouth Castle was built as an artillery fort to protect Dartmouth harbour from the threat of French and Spanish attack. It is believed the earliest parts of the castle date from the 1380s and incorporated the already existing local chapel of St Petroc within its walls. The castle was expanded in the fifteenth century and additional gun batteries were built in the 1540s. It is really interesting to note that one of the key parts to the defence of the harbour at the time was to stretch an iron chain across the harbour to a tower at Godmerock. During the English Civil War, the Parliamentarian town of Dartmouth was besieged, and Prince Maurice took the castle (and its tiny garrison of five men) with ease in 1643 by positioning his artillery on the higher ground overlooking the castle – and its seaward-facing defences. It is thought that an earthwork fort called 'Gallants Bower' was built to protect this vulnerable position, but in January 1646, Sir Thomas Fairfax

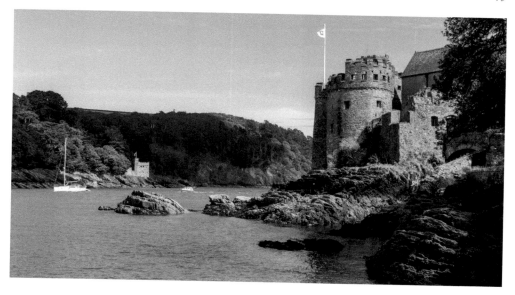

Above: A view of Dartmouth Castle and Kingswear Castle on the opposite bank. (Courtesy of Matthew Hartley CC BY-SA 2.0)

Right: Dartmouth Castle has a number of cannons still in situ. (Courtesy of Gerry Labrijn CC BY-SA 2.0)

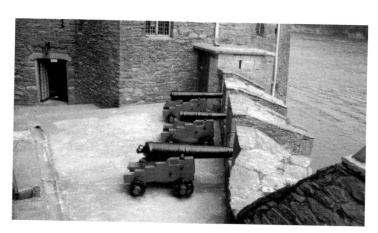

led a Parliamentary army to retake Dartmouth and forced the surrender of the Royalist's castle commander. By 1748 a new gun position called the Grand Battery was added to the castle along with twelve guns. The castle was again upgraded in 1859 with modern artillery, but by the twentieth century the castle was considered redundant and was open to visitors as a tourist attraction. It was, however, brought back into use during the First and Second World Wars as a coastal observation point.

HEMYOCK CASTLE

Located in the Culm Valley on the western side of the village of Hemyock, Sir William Asthorpe acquired royal permission to build a new castle on the site in 1380, giving him power, protection and prestige. With a large gatehouse, moat and a high curtain

wall over 1 metre thick, the castle would have looked impressive with its seven circular towers dominating the surrounding area. By the sixteenth century the castle was largely in ruins, save for a tower or two, but when the English Civil War broke out in 1642, a Royalist named Lord Poulett took the castle, only for it to be later claimed by the Parliamentians and used as a prison. When Charles II was restored to the throne, parts of the castle were torn down and then it fell into different hands, resulting in Castle House being built inside the walls and leaving the private property that stands there today.

KINGSWEAR CASTLE

Kingswear Castle was built between 1491 and 1502, a few years later than Dartmouth Castle and on the opposite bank of the River Dart, providing increased protection for the river entrance and harbour. Similar in design to Dartmouth Castle, it had artillery based there, but by the end of the sixteenth century, Kingswear was little used as the guns at Dartmouth were powerful enough to protect the whole of the river. It fell into ruin, but in the middle of the nineteenth century it was transformed it into a summer residence, and it is now a holiday let.

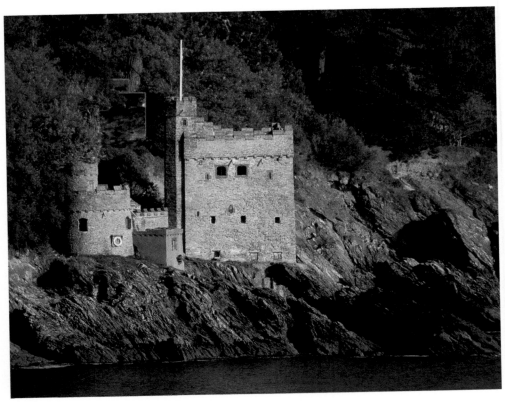

A view of Kingswear Castle. (Courtesy of Nilfanion CC BY-SA 3.0)

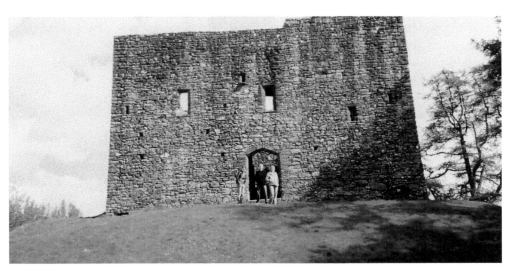

The remains of the stone keep at Lydford. (Author's collection)

LYDFORD CASTLE

The small village of Lydford actually has two castle structures to talk about. The first, a small ringwork built in the years immediately after the Norman invasion of 1066, served to keep the local population in check, and aside from these earthworks, nothing else remains of this defensive position. Lydford's other castle was constructed in 1195 and was used primarily to administer the laws of the land as a court – and as a prison for those who broke them. It is possibly the earliest example of a purpose-built prison in England. Built on a mound of earth, the two-storey tower measures 16 metres in each direction.

OKEHAMPTON CASTLE

The motte-and-bailey castle at Okehampton traces its origins to the immediate aftermath of the Norman Conquest of 1066. As sporadic violence flared up from discontent locals, a Norman lord, Baldwin FitzGilbert, was given significant lands in the county in return for quashing a rebellion in 1068, and so began the building of the castle. The location was paramount. The long, thin, rocky outcrop was perfect as it protected one of the significant routes from Devon to Cornwall, as well as two nearby fords across the West Okement River. A new town was established near to the castle and this became known as Okehampton. The castle was successful in providing a strong military base from which to keep the local population in check, and it was later requisitioned in 1194 by King Richard I to assist in the royal defence of Devon, with some additional works being carried out on the site. Towards the end of the thirteenth century the castle had fallen into a state of disrepair, before it was modified to become less of a military stronghold

and more of a hunting lodge and retreat. In the fifteenth century, the Courtenay family became embroiled in the War of the Roses, resulting in the castle being confiscated by King Edward IV. By the mid-sixteenth century the castle began to fall into decay, so much so that in 1643 during the English Civil War, despite the Battle of Sourton Down taking place nearby, neither side used the castle as it no longer served a military purpose. Today, its ruins stand as a reminder of the importance this castle once had.

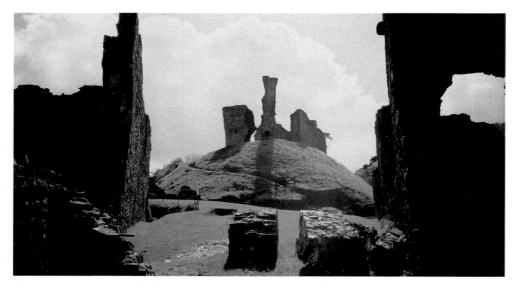

The atmospheric ruins of Okehampton Castle. (Author's collection)

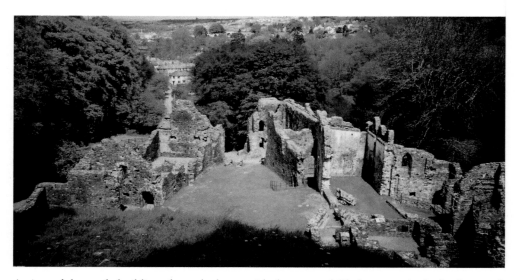

A view of the castle buildings from the keep, with the town of Okehampton in the background. (Author's collection)

PLYMOUTH CASTLE

In 1340 and 1377, the fishing village of Plymouth was attacked by a flotilla of French pirates, which prompted the construction of a castle and other earthworks. Building began in the early part of the fifteenth century, with curtain walls 4 metres high and each corner having a great round tower as well as a chain that could be raised to prevent access to Sutton Pool. A barbican protected the castle's gateway and in 1400 its guns drove off a fleet of French ships, and in August 1403 it provided a safe haven to the locals when a Breton army landed at Cattewater and attacked the town. In the years that followed the castle was neglected, and although it was still standing in 1588 during the Spanish Armada, weaponry had moved on enough for Sir Francis Drake to use the castle stone to build a new artillery fort on the Hoe. During the English Civil War, which saw Parliamentarian Plymouth besieged by Royalist troops, the castle was occupied by the defenders. This was the last action Plymouth Castle saw. Mount Batten Tower and the Royal Citadel became the new defences of the city, and with a population boom and a demand for new housing, the old crumbling castle saw its stone being taken for new projects. Today only a small portion of the gatehouse has survived.

All that remains of Plymouth Castle.

PLYMPTON CASTLE

An earth and timber motte-and-bailey castle was built between 1068 and 1100 on the site of a much older Saxon fortification. Surrounded by a ditch and with large ramparts, it helped in keeping the local population in check. However, in 1136 the then owner of Plympton Castle, Baldwin de Redvers, Earl of Devon, rebelled against the king and with the threat of royal reprisals, Baldwin fled the country, leaving his castle to be burnt to the ground. By the thirteenth century, the castle had been rebuilt in stone and in February 1224, the then owner Fawkes de Breaute was ordered to surrender Plympton and Bedford castles. When he refused, Robert Courtenay was sent to capture Plympton Castle. It is believed that the garrison held out for fifteen days before surrendering after which Fawkes fled abroad and the Courtenay family took over ownership. The castle fell into a state of semi-disrepair but was upgraded at the outbreak of the English Civil War and used by Royalist troops as they besieged Parliamentarian Plymouth. Since then, the castle was abandoned, and nothing remains except the rather impressive motte.

POWDERHAM CASTLE

Located on the west bank of the River Exe estuary, Sir Philip Courtenay began constructing a fortified manor here in 1391. The Courtenay Earls of Devon had Tiverton Castle as their main stronghold and were a powerful family, but during the Wars of the Roses, the Bonville family of Shute, the Courtenay's enemies, took control of Powerham through marriage. As a result, in 1455 Thomas de Courtenay, 5th Earl of Devon, brought a private army of 1,000 men, seized control of Exeter and laid siege to Powderham for two months. On 15 December 1455 the Earl of Devon and

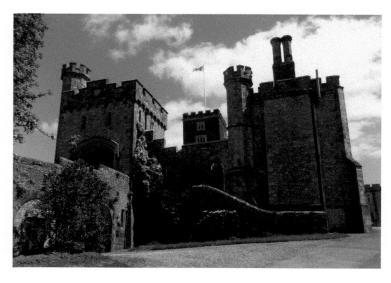

A view of the gatehouse to Powderham Castle, built in the Victorian era.

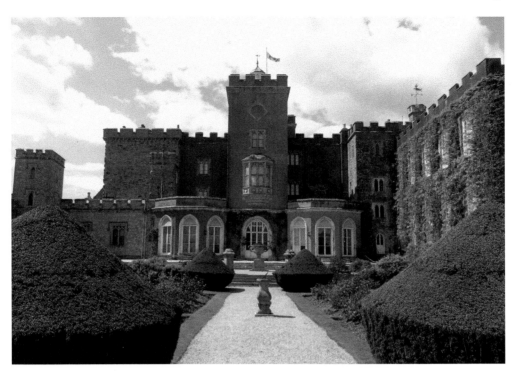

A view of the east garden at Powderham.

Lord Bonville met at the First Battle of Clyst Heath in Exeter, where Bonville was eventually defeated and Courtenay pillaged Shute. By the time of the English Civil War, Powderham Castle had around 300 Royalist soldiers garrisoned there, who withstood a Parliamentarian attempt to take the castle in December 1645. However, a few months later in January 1646 it was taken, and the castle was badly damaged but remained in the hands of the Courtenays. Since then, modifications have been made to turn this into a fine home, with only one of the original six towers, in the north-west, still standing.

ROUGEMONT CASTLE

Two years after the Norman Conquest of England, it is believed that the Anglo-Saxons of Devon, Somerset and Dorset, together with the citizens of Exeter and Harold Godwinson's mother who lived in the city, refused to swear loyalty to William or pay the taxes he demanded. So, in 1068 he marched to Exeter and lay siege to the city where he was met with fierce armed resistance. After eighteen days, the city finally surrendered, with the agreement that William would not harm its inhabitants, take their possessions, or increase the amount of tax they had to pay. With this, building began almost immediately of Rougemont Castle (sometimes known as Exeter Castle). The Domesday Book of 1086 reported that forty-eight houses had been destroyed

in Exeter since the king came to England, with many historians interpreting this to mean that these houses were cleared for the building of the castle. A large stone gatehouse, two corner turrets and ramparts were constructed and then enhanced in the following years with the construction of a protective barbican over the city side of the drawbridge.

In 1136, as part of his rebellion against King Stephen, Baldwin de Redvers successfully seized the castle and held out from counter attacks from Stephen's men for three months, until the failure of his water supply, which had been provided by a well. It is thought that the barbican was captured and destroyed at this time, along with a tower. In the late twelfth century, an outer bailey consisting of a wall with an outer ditch ran from the eastern city wall on the north side of Bailey Street to the western city wall near the current city museum. In 1497 the castle is said to have been badly damaged during the Second Cornish uprising when Perkin Warbeck and 6,000 Cornishmen entered the city, and by 1500 the original gateway was no longer used. Despite its illustrious past, the remains of the castle were in no fit state to be of any real use during the English Civil War (although the gatehouse was used as a prison), and despite there being at least four artillery batteries on the site, the city fell to the Royalists in 1643 and then back to the Parliamentarians in 1646. The County Court was built on the site in the eighteenth century, and today much of the old wall can still be found in situ around the city, along with the gatehouse and a tower.

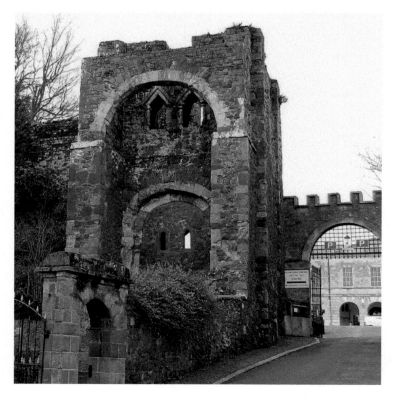

The gatehouse of Rougemont Castle in Exeter. (Courtesy of Juan J. Martínez CC BY-SA 2.0)

ROYAL CITADEL, PLYMOUTH

The outbreak of the Second Anglo-Dutch War in 1665 resulted in the commissioning of a major new fortification, the Royal Citadel, to protect Plymouth. Built partly on the site of 'Drake's Fort' – an earlier artillery position built by Sir Francis Drake – it retained these fortifications within its design, while also having a dry ditch and large stone curtain wall surrounding the vast new position. The land was seized by the Crown, and soldiers from the Duke of Cornwall's Regiment were used to build the 12-metre-high walls in just two years. Being the principle defensive structure

Above: View of the Royal Citadel and Plymouth Hoe to the left.

Right: The gigantic walls of the Royal Citadel. (Author's collection)

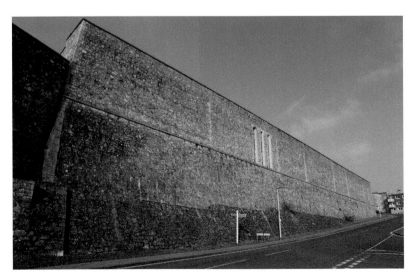

of the city, the Royal Citadel was regularly strengthened in the eighteenth and nineteenth centuries and has been continually used as a barracks. Today, the Royal Citadel is home to 29 Commando Royal Artillery, but the Ministry of Defence have announced their intention to withdraw from the installation by 2024.

TIVERTON CASTLE

It is no surprise that the town that straddles the rivers Exe and Lowman, a site of historic strategic importance, has the remains of a castle set in a defensive position overlooking the waterways. As the seat of the court of the 'Hundred of Tiverton', the castle was first built in 1106 by Richard de Redvers after he was granted the large and important manor of Tiverton by Henry I. The wooden motte-and-bailey castle on the bank of the River Exe was redesigned and remodelled in the thirteenth and fourteenth centuries, making it an imposing stone structure that became a Royalist stronghold during the English Civil War of the seventeenth century. Despite this, Parliamentarian troops laid siege to the castle, setting up their headquarters at Blundell's School, and stationed their artillery on Shrink Hills approximately half a mile from Tiverton Castle.

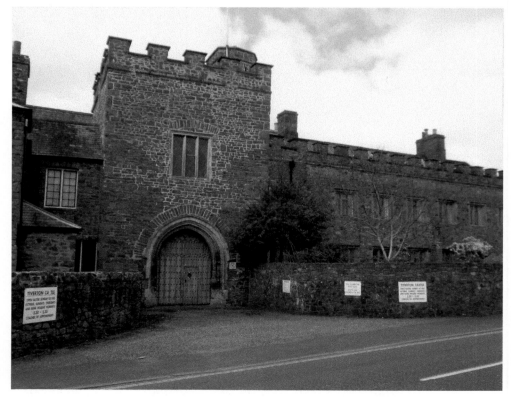

The gatehouse of Tiverton Castle. (Author's collection)

It is said that while they were still finding their range, a lucky shot hit one of the chains holding up the castle's drawbridge allowing them to gain entry, ending the siege almost before it had started. In taking the castle, the majority of the defensive structures of this once vast bastion were demolished to prevent any military reuse of the structure by the Royalists. Today, the part Grade I listed castle is privately owned, but is opened on certain days of the year.

TOTNES CASTLE

Occupying a prominent position on a hill above the town, Totnes Castle was first constructed of wood in the immediate aftermath of the Norman Conquest of 1066. It is believed that a few hundred years later, the wooden structures were replaced with the stone ones, but by 1326 the castle was ruined and no longer used. However, the castle was refortified with a new shell keep, and that we see today – making this one of the best-preserved motte-and-bailey castles in the country. The simple, yet effective, stone keep at the top is made from Devon limestone and has incredible views over the town, making those early years of control easy for the crown. The curtain walls from this period remain intact too, and although the castle was occupied for a period during the English Civil War, it saw no action of note. It is now a Grade I listed building and maintained by English Heritage.

Totnes Castle is one of the best examples of a Norman motte-and-bailey castle in England. (Author's collection)

Chapter 4

Somerset

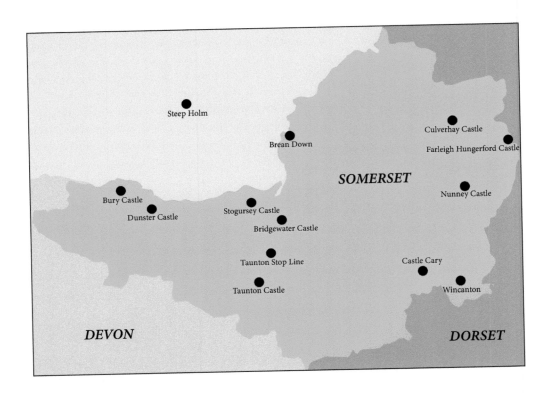

BREAN DOWN

One of the most spectacular settings in Somerset, Brean Down has a long military history due to its prominent position. Iron Age artefacts have been found on this strip of land that protrudes into the Bristol Channel and are evidence of it being occupied as an Iron Age hill fort. In 1864, construction started on a Palmerston fort, designed by Lord Palmerston at the bequest of Queen Victoria who was concerned about the strength of the French Navy, and positioned to help protect the approaches to Bristol and Cardiff. Taking seven years to build, the fort was staffed by around fifty soldiers of the Royal Artillery Coast Brigade and had seven 7-inch muzzle-loading guns, which could

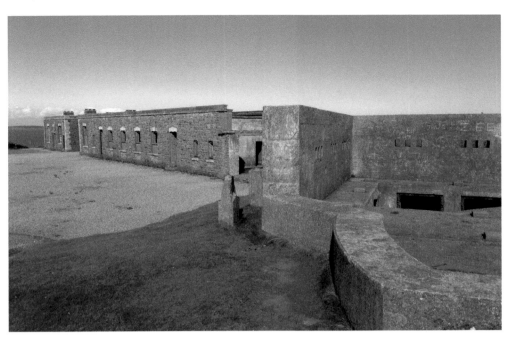

The Palmerston Fort on Brean Down was built in 1864 to protect the approach to Cardiff and Bristol against the French navy. (Author's collection)

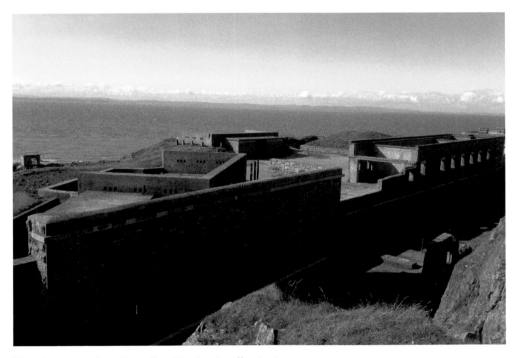

The views stretch on for miles. (Author's collection)

fire almost 1,000 metres and weighed over 5 tons. However, the fort was never used in action and it closed in 1900 when No. 3 magazine exploded. At the outbreak of war in 1939, the fort was rearmed with two 6-inch naval guns as it became a coastal battery that also had searchlights, anti-aircraft guns and a range of pillboxes. Manned by 365 and 366 Royal Artillery Coast Batteries of 571 Coast Regiment, it was also a test launch site for experimental weapons and rockets until the end of the war in 1945. At the other end of Brean Down, there are six Lewis-gun emplacements on the northern cliffs overlooking Weston-super-Mare, and with so much still in situ, it is well worth a visit.

BRIDGWATER CASTLE

In the year 1200, King John granted a charter to construct a castle at Bridgwater and twenty years later, the lord of the manor of Bridgwater, William Brewer, built a grand and imposing base with which to expand the town – and his own wealth. The castle was built on the only raised ground in the town and as well as controlling the crossing of the town bridge, it also had a water gate, allowing access to the vital quay. Covering over 8 acres, the castle utilised the River Parrett by having a tidal moat, which is believed to have been up to 20 metres wide in places. Documents show there was a dungeon, chapel, tower and stables within the walls of the castle, and over the year's further towers were added. As well as keeping the local population in check, there are some notable moments in the castle's history. During the Second Baron's War, fought

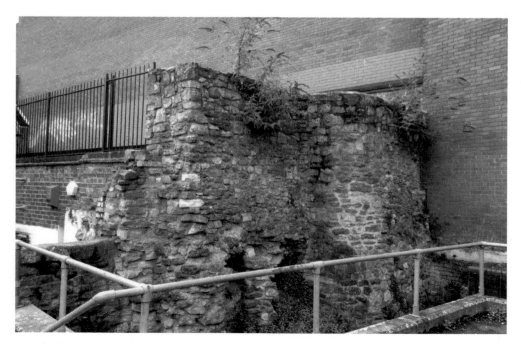

Very little remains of the once vast Bridgwater Castle. (Author's collection)

against Henry III between 1264 and 1267, Bridgwater Castle was held by the barons against the king. The castle remained in the hands of the Mortimer family and in the Despenser War of 1321, the crown, on behalf of Edward II, occupied the castle until 1326 to stop Roger Mortimer using it. After this, the upkeep of the castle started to wane, and by 1548 it was in part ruin. Despite this, in 1642 the English Civil War broke out and a garrison was established at the castle, led by Royalist Edmund Wyndham. He remained Governor of Bridgwater until the town and castle fell to Oliver Cromwell and his Parliamentarians on 21 July 1645. By now the castle was in poor condition, and by the time of the Monmouth Rebellion in 1685, very little remained, which led to rebel troops refortifying the town when they became hemmed in on 3 July 1685. The ruins of the castle were gradually demolished and replaced with new buildings and, sadly, very little remains of this once vast stronghold, save for a portion of the wall and water gate located on West Quay. The modern-day streets of Bridgwater now bear reminders of this grand past, named as they are: King Square, Queen Street, Northgate and Castle Moat.

BURY CASTLE

Near the village of Selworthy are the earthwork remains of Bury Castle, an Iron Age hill fort built by Bury Wood. The simple circular enclosure is protected by the National Trust and is open to the public all year round.

The site of Bury Castle. (Courtesy of Roger Cornfoot CC BY-SA 2.0)

CASTLE CARY

Another Somerset village that boasts the remains of an old motte-and-bailey castle, Cary Castle was situated atop Lodge Hill and although there are only earthworks that remain, excavations carried out in the late nineteenth century suggest that a 24-metre stone keep once occupied the site.

CULVERHAY CASTLE

The small village of Englishcombe is home to the remnants of Culverhay Castle. The site once consisted of a stone keep and outbuildings, but now only the banks and earthworks remain, and little is known about its history.

The earthwork remains of Culverhay Castle. (Courtesy of Rick Crowley CC BY-SA 2.0)

DUNSTER CASTLE

There is a selection of Iron Age hill forts around Dunster, such as Bat's Castle and Black Ball Camp, which are the earliest examples of defensive activity in the area. In the aftermath of the Norman Conquest of 1066, William the Conqueror's tenant-in-chief, William I de Moyon, became the Sheriff of Somerset and built Dunster Castle on the top of a hill by the time the Domesday Book was written in 1086. Originally built of wood, a stone keep was soon built along with towers and many buildings as the castle acted a point of power for the de Moyon family for the next 400 years. During the English Civil War in the 1640s, the castle switched hands between the Royalists and Parliamentarians a number of times! Thomas Luttrell, the owner of the castle, supported the Parliamentarians and drove back an attack by the Royalists in 1642, who regrouped and attacked a year later in 1643, when Luttrell surrendered and swapped sides! However, in 1645 Robert Blake led a Parliamentarian 'Siege of Dunster' and installed a new garrison in 1646, who stayed in control for the next four years before partially destroying some parts of the castle. In the centuries that followed the upkeep of the castle proved to be very expensive, and it saw little by way of military action as it became more of a grand home. By the time of the Second World War parts of the Dunster estate, including the castle, were used as a convalescent home for injured naval officers. On Dunster beach, two pillboxes were constructed (still standing today) and a camp complete with Nissan huts was set up for the military, who were building the coastal defences in the area. Today, Dunster castle is run by the National Trust.

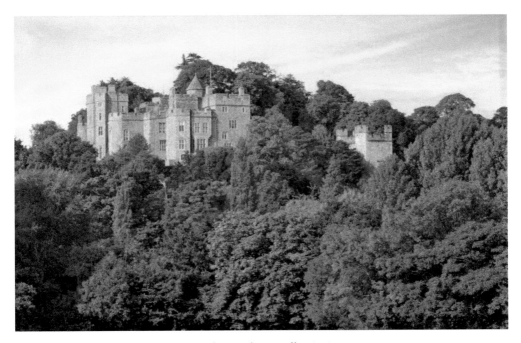

A view of the impressive Dunster Castle. (Author's collection)

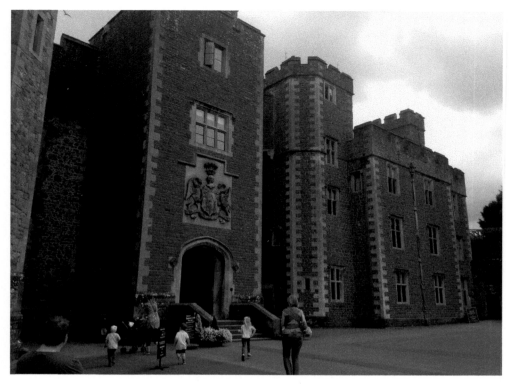

The grand entrance to the castle. (Author's collection)

FARLEIGH HUNGERFORD CASTLE

Right on the border with Wiltshire sat on a low spur overlooking the River Frome is the vast remains of Farleigh Hungerford Castle. Building of what is now the inner court on the site of a manor house was started in 1377 by Sir Thomas Hungerford, who was the first person to hold the office of Speaker of the House of Commons. His son Sir Walter Hungerford, who fought at the Battle of Agincourt, extended the castle by constructing an outer court between 1430 and 1445 and the footprint of the bastion, along with a number of buildings that are still standing. During the English Civil War, the Hungerford family declared themselves to be Parliamentarians only to see the castle fall into the hands of the Royalists in 1643. It was retaken by Parliament right at the end of the war in 1645, which meant the castle avoided any slighting – the partial or complete construction of a fortification making it unusable as a fortress. The castle left the Hungerford family in 1686 and by 1730 it was in a state of disrepair, with much of it being broken up for salvage, and this is what we see today. As you walk up towards the gatehouse the scale of the castle becomes apparent as you can see nothing but walls stretching out in front of you. Once inside there are a mixture of well-maintained buildings and the footprints of structures that no longer exist. Two towers dominate the skyline, along with the Priest's House and Chapel. St Leonard's

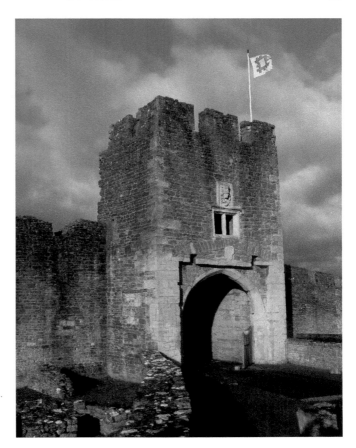

The eastern gatehouse of Farleigh Hungerford Castle. (Courtesy of Nick Sarebi CC BY 2.0)

Chapel, with its wall paintings, stained-glass windows and carved family tombs of the Hungerford's, is still used for local events while there are archaeologically important coffins made of lead in the crypt.

NUNNEY CASTLE

Built in 1373, the now ruined castle of Nunney was constructed on the site of a manor house. It is essentially a tower keep surrounded by a moat and was constructed by Sir John de la Mare, a local knight, in response to the possibility of a French invasion. This never happened and the castle was used as an impressive home, receiving various redesigns over the years. At the start of the First English Civil War in 1642 a Royalist army was garrisoned at Nunney Castle and in 1645 a Parliamentarian army opened fire with cannons in an offensive that breached the castle walls and forced those inside to surrender. This was the only real military action that Nunney saw, with the castle swapping hands numerous times over the next few hundred centuries, gradually falling into a state of ruin.

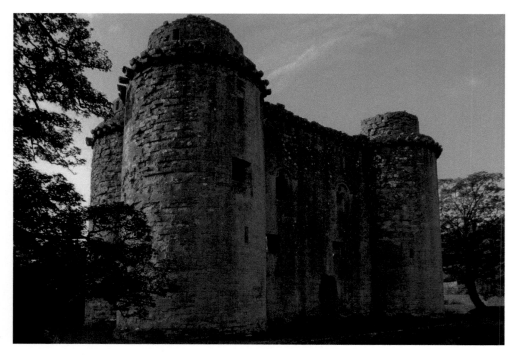

Nunney Castle.

STEEP HOLM

This kilometre-long island in the Bristol Channel has had a military presence on it since 1865, when work began on building a Palmerston fort, forming part of the country's strategic coastal defence system during the Napoleonic Wars. Completed in 1869, there were six gun emplacements, a master-gunners house, barracks, a water

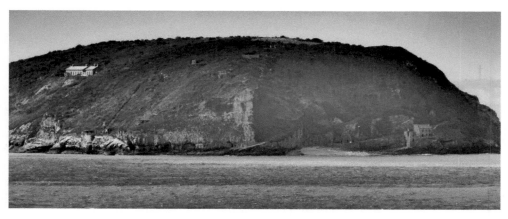

The island of Steep Holm in the Bristol Channel. (Courtesy of Stewart Black CC BY 2.0)

tank and even a small inn. Military control of the island remained until 1908, when it was leased out, but was soon requisitioned back in the First World War, where the facilities were updated. At the outbreak of the Second World War, the existing fortifications were upgraded, including the building of a new jetty, searchlight batteries and even an underwater telegraph cable connecting it to Brean Down Fort! After the war, the military ceased operating on the island but many of the islands' structures remain.

STOGURSEY CASTLE

Stogursey Castle is a motte-and-bailey castle built in the village of the same name on the Quantock Hills. Built around 800 years ago, it still retains its water-filled moat. During the War of the Roses in the 1450s, the castle was destroyed and left to ruin for the next 200 years or so, before a house was built inside it. Although the castle was left in its decapitated state, the house was rebuilt, and it is now available to stay in as a holiday home.

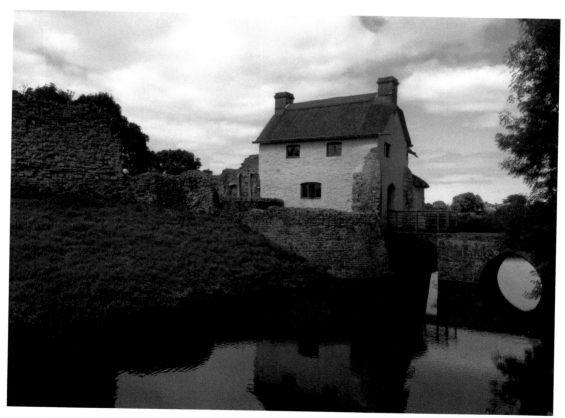

The remains of the motte-and-bailey Stogursey Castle. (Author's collection)

TAUNTON CASTLE

In the early twelfth century, the Bishop's Hall of a former Augustinian priory was converted into a small castle, and by 1138 it had grown into a significant stronghold. The Barons' Revolt of 1216 was successfully defended against at Taunton Castle, and over the next century the keep is thought to have grown in size to 20 metres by 30 metres. The son of Simon de Montfort, the man who led a rebellion against King Henry III in the Second Barons' War, was held prisoner within its walls for a number of years, and during the Tudor era buildings were added and the castle modified. By the First English Civil War in the 1600s Royalist troops used the castle as a defensive site because of its strategic importance controlling the main road from Bristol to the West Country. In September 1644, Parliamentarian forces under the command of Colonel Sir Robert Pye and Robert Blake surrounded the town and claimed it without any fighting. The Royalists returned in March 1645 to find some earthwork defences and small forts in place around the town and fierce fighting took place, forcing the Parliamentarian troops to once again move back to the safety of the castle. The Royalists were unable to break through the perimeter defences of the castle despite repeated attempts and were themselves forced to retreat from the town when another Parliamentarian army turned up just in time as supplies within the castle dwindled. By May 1645 the Royalists returned with a large army of over 10,000 troops and besieged the town for a third time. Despite their numbers, the Royalist siege was fairly lax and allowed supplies into the town. The Parliamentarian troops inside the town kept the Royalist force at bay for over two months, occupying them when they could have been deployed elsewhere in the country by King Charles. By July, a third Parliamentarian relief force headed to the town, making the Royalists withdraw yet again. It is thought that over half the town was destroyed during this time and less than twenty years later, the Royalists got some sort of revenge, with the infamous

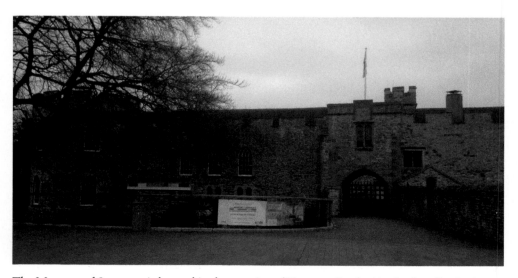

The Museum of Somerset is housed in the remains of Taunton Castle. (Author's collection)

Judge Jeffreys using the Great Hall at Taunton Castle to conduct his 'Bloody Assizes'. In September 1685 in the aftermath of the failed Monmouth Rebellion, over 500 supporters of James Monmouth were tried, resulting in over 140 being hung, with their remains being displayed in the town, and across the county, as a warning to others. For the next hundred years or so, the castle was used as a prison but fell into a state of disrepair. Thankfully the Member of Parliament for Taunton in 1786, Sir Benjamin Hammet, began restoring the castle and a century later in 1873, the Somerset Archaeological and Natural History Society purchased the castle and restored the Great Hall. Today, Taunton Castle is home to the Museum of Somerset and the Somerset Military Museum.

TAUNTON STOP LINE

In 1940, as the threat of German invasion was at its height in the Second World War, a series of linked fortifications were created across Somerset, Dorset and Devon. Known as the Taunton Stop Line, pillboxes, gun emplacements and numerous types of anti-tank obstacles were built in order to hold up any potential Nazi invasion. Thankfully never put to the test, the vast majority are still standing today.

WINCANTON

For a small town, Wincanton has quite an eventful past. Reported to have been the site of battles between the Saxons and the Danes, after the Norman Conquest of 1066 a number of motte-and-bailey castles were built in the area, with some earthworks of Cockroad Wood Castle, Ballands Castle and Castle Orchard still remaining. Other than this, very little is known about these positions.

The Taunton Stop Line stretches over 50 miles through Somerset, Dorset and Devon. (Author's collection)

Chapter 5

Wiltshire

Aston Keyes Castle

Bincknoll Castle

Barbury Castle

Castle Combe Castle

Marlborough Castle

Devizes Castle

Ludgershall Castle

Castle Hill, Mere

Old Sarum Castle

Wardour Castle

The remaining earthworks of Ashton Keynes Castle. (Courtesy of Martin Elliott CC BY-SA 2.0)

ASHTON KEYNES CASTLE

Built in the twelfth century by the Keynes family to help maintain law and order over the locals, this fortification was thought to have been a cross between a ringwork defence and a motte-and-bailey castle. Some historians think that this might be the castle that was captured by King Stephen from Miles of Gloucester during the Anarchy of 1135–53. Excavations over the years have revealed some fragments of pottery and floor tiles, but sadly nothing now remains of this castle except some earthwork ditches.

BARBURY CASTLE

Barbury Castle is one of the most impressive Iron Age hill forts in the entire country, let alone Wiltshire. Occupying a 12-acre site on the top of Barbury Hill, on the northern edge of the Marlborough Downs, it has two defensive earthwork ramparts and two deep ditches that would have provided very good protection to those inside. Excavations over the years have found evidence of the site being used by the Romans and it is believed around forty huts were once inside the enclosure. Because of its height and location on the outskirts of Swindon, it is not surprising that the fort was used for anti-aircraft emplacements during the Second World War, with US anti-aircraft guns being deployed here to help protect the vital war factories of Swindon and the nearby airfields.

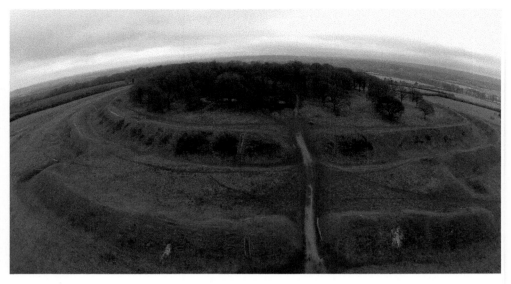

A spectacular view of Barbury Castle Iron Age hill fort. (Courtesy of Mark Way CC BY-ND 2.0)

BINCKNOLL CASTLE

Located to the west of the village of Wroughton, Bincknoll Castle is the site of an Iron Age hill fort, although some suggest its origins are from a slightly later time. In the aftermath of the Norman Conquest, Gilbert of Breteuil became the owner of manors around the Broad Hinton area, and it is thought that he built a castle on this older site to oversee them. It is easy to see why. The steep natural banks provide very good natural protection, and the earthworks that remain there today indicate that a motte-and-bailey castle was built here with two ditches – each over 2 metres in depth – adding to the already strong defences. The need for the castle diminished over the years, and everything that could be reused elsewhere was, meaning that today only the steep earthwork remains of the enclosure are still there.

CASTLE COMBE CASTLE

Built by Reginald de Dunstanville in 1140 on the site of an entrenched Celtic camp that was abandoned when the Romans took control, Castle Combe Castle sits half a mile outside the village of the same name. On a commanding position overlooking the valley, the summit covers around 8 acres and is surrounded by a defensive ditch, and this coupled with the steep sides would have made this a difficult place to capture. As the centuries passed, the need for a fortified defensive position waned, and the castle gradually fell into disrepair as the manor house was built in the fourteenth century. Although the site today is overgrown, some of the earthworks are still visible, and it is believed that some stonework is located in the undergrowth.

Castle Hill overlooking the village of Mere. (Courtesy of Barn Elms CC BY-SA 2.0)

CASTLE HILL, MERE

In 1243, Richard, Earl of Cornwall, acquired the village of Mere and began building a castle here in 1253 as a show of his power. Overlooking the village was a chalk ridge known as 'Long Hill', and this was quickly chosen as the site. The top of the hill was flattened, and a 5-metre ditch was dug along the western side, which is where the entrance was to be. Stone was imported from nearby quarries for the rectangular castle, which is thought to have had an impressive six towers, as well as inner and outer gates, a well, hall and chapel. In its day, it would have stood out for miles, dominating the landscape around Mere, and it is no doubt that the village grew significantly in size because of this. When Richard died in 1272, his son Edmund took control, and the manor of Mere continued to prosper until his death in 1300, when it was taken by the Crown. The castle was likely improved and renovated at this time due to the threat of rebellion in the country, but during the fourteenth century the castle became abandoned due to its waning significance. It is said that Richard II took the lead from the castle roofs in 1398 in order to reuse it at Portchester Castle in Hampshire, and the stonework was taken over the years and used for new construction work in the town, leaving only the earthworks that we can see today. Now a Scheduled Monument, a flagpole and a memorial to the 43rd Wessex Infantry Division, which was constructed in the aftermath of the Second World War, are located on the castle site.

DEVIZES CASTLE

The town of Devizes developed around a Norman motte-and-bailey castle that was built here in 1080 in the aftermath of the Norman Conquest. The castle must have been quite substantial as it held Robert Curthose (eldest son of William the Conqueror) as a prisoner in 1106, and there he remained for twenty years. Records indicate that the wooden structure burnt down in 1113 but was quickly rebuilt in stone by Roger of Salisbury in 1120. In 1141 the town was granted a charter permitting regular markets and these were held in the space that is now outside St Mary's Church, which quickly became the centre of the town. During the twelfth-century civil war between Stephen of

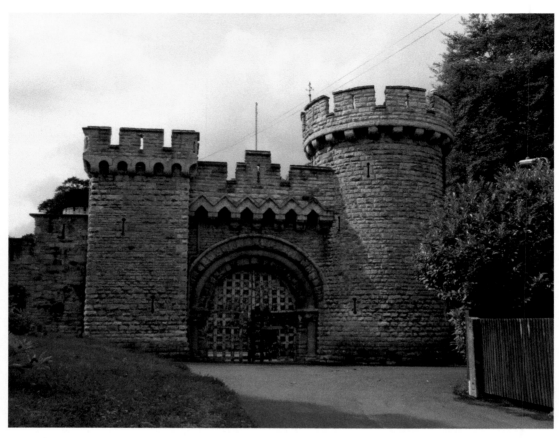

The gatehouse to Devizes Castle. (Courtesy of Hugh Llewelyn CC BY-SA 2.0)

Blois and Matilda, known as the Anarchy, the castle switched hands many times. Over the next 200 years, the town continued to grow as a centre of commerce for craftsmen and traders, with wheat, wool, cheese and butter being increasingly important. The castle remained the focal point for law and order over the town for the next few centuries but that changed in the aftermath of the English Civil War. In 1643, Parliamentarian forces besieged the Royalist troops inside until they were relieved by a force from Oxford, which ensured Devizes and its castle remained in Royalist hands. However, in 1645, Oliver Cromwell attacked the castle with 5,000 men and heavy artillery, forcing those inside to surrender and ultimately resulting in the castle being almost totally destroyed on the orders of Parliament in 1648, with the stone being reused for buildings in the town. The footprint ruins of the castle lay in the ground until 1838 when Devizes tradesman Valentine Leach purchased the land and built his own Victorian era castle over the coming decades. The current castle, still privately owned but now a Grade I listed building, sits in over 2 acres of land with turrets, towers and castellations, and gives us a tantalising glimpse of what the original castle might have been like.

LUDGERSHALL CASTLE

The ruins of Ludgershall Castle in the far east of the county are all that are left of a castle built in the eleventh century by Edward of Salisbury, Sheriff of Wiltshire. By around 1100 it went into the possession of the Crown, and a man called John the Marshal (recorded as the king's castellan) is said to have strengthened the structure. At this point a northern enclosure was constructed on site, which contained all the important buildings, including a great hall and a tower with royal living quarters. King John then updated the site, transforming it from a castle to keep the population in check to a hunting lodge in 1210. Ludgershall was an important place in medieval England, with King John's son, King Henry III, using it regularly. By the fifteenth century the castle fell into disuse and like many buildings that had outlived their purpose, the vast majority of the stone was taken and used for other projects. The site was only excavated for the first time between 1964 and 1972 and was then listed as a Scheduled Ancient Monument in 1981. Significant earthworks remain, although they have been greatly altered by quarrying on the site, and parts of three large walls are left for you to visit today.

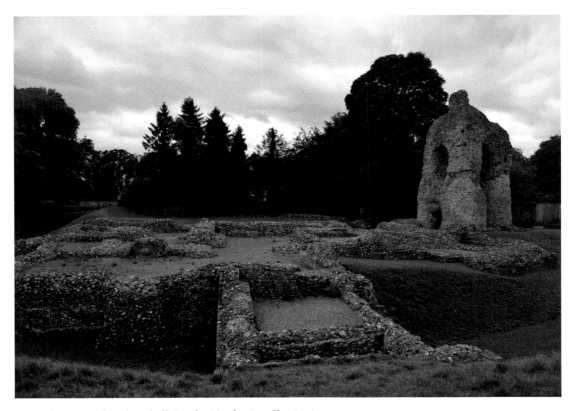

The ruins of Ludgershall Castle. (Author's collection)

MARLBOROUGH CASTLE

In the aftermath of the Norman Conquest, William the Conqueror assumed control of the Marlborough area in 1067 and built a wooden motte-and-bailey castle, sited on the prehistoric 'Marlborough mound'. As a result, the town is noted in the Domesday Book of 1087 and the castle was then completed around 1100. William established a mint in the town, nearby Savernake Forest became a royal hunting ground, and the castle became an official royal residence. King Henry I spent Easter in the town and King Henry II often stayed at the castle, which was then strengthened in stone in 1175. King John was married here and spent time in Marlborough, where he established a treasury and granted weekly markets to be held on Wednesdays and Saturdays – something that continues to this day. King Henry III married in the town and even held Parliament here in 1267. These 200 years saw the castle well maintained with an understandably strong garrison, but sadly by the end of the fourteenth century the castle had lost its importance, fell into disrepair, and is said to have been in ruins by 1403. Like most notable towns, the English Civil War had an impact on the local population. The town was Parliamentarian, despite the Seymour family, who had acquired the castle site, being loyal to the king, and as a result in 1642, Royalist troops infiltrated the town down its small backstreets and alleyways. They looted what they could, set many buildings on fire, and marched over 100 to Oxford in chains. But the castle was now nonexistent. The Seymour family had torn down the ruins and replaced them with a rather grand house, which today makes up much of Marlborough College – and the tree-covered earthworks mound is still easily notable within the grounds of Marlborough College.

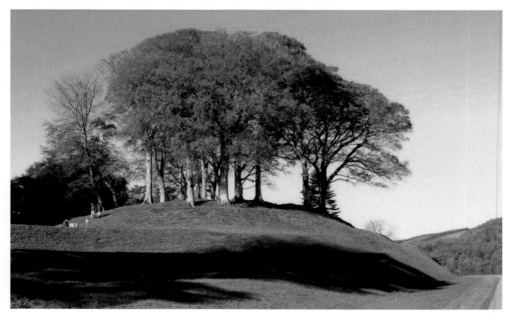

Mount Marlborough – all that remains of the castle. (Courtesy of Billy McCrorie CC BY-SA 2.0)

OLD SARUM CASTLE

There is evidence of a protective hill fort being built here during the Iron Age in around 400 BC with gigantic banks and ditches surrounding the hill, measuring 400 metres in length and 360 metres in width. With a double defensive bank, the site was occupied during the Roman period, but interestingly archaeologists do not think it was used by the Roman army. It is known that Cynric, King of Wessex, captured the hill in AD 552, and centuries later, in 960, King Edgar assembled a national council at Old Sarum to plan a defence against the Danes. In the years that followed, it was abandoned and ransacked by the Danes in AD 1003. However, the defensive properties of the site were recognised by the Normans, and only four years after the conquest of 1066, they constructed a motte-and-bailey castle, and it is these earthworks and designs that remain so prevalent today. Held by the Norman kings themselves, Herman was installed as the first Bishop of Salisbury and together with Osmund, who was a cousin of William the Conqueror, they started the construction of the first Salisbury Cathedral. In the centuries that followed, a bigger town started to develop, with homes building up beside the ditch that protected the inner bailey and Norman castle and kilns and furnaces being constructed. This saw Sarum's role as a castle diminish, and in the centuries that followed it fell into disrepair. By 1219, the decision had been made to relocate the cathedral, which was built within the castle walls, to a new location due to issues with strong winds, insufficient housing and that the soldiers of the royal fortress restricted access to the cathedral precinct. The inhabitants of the new city that was springing up around the new cathedral –

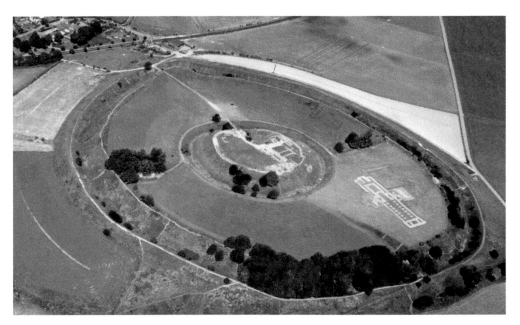

An aerial view of Old Sarum Castle.

Salisbury – gradually took the stone, wood and metalwork from the old cathedral and its castle, and in 1322 King Edward II ordered the castle's demolition. Today, the impressive earthwork defences and the stone footprint of the castle and its cathedral remain as a mark to this once important place.

WARDOUR CASTLE

Around 15 miles west of Salisbury are one of the most impressive sights in the county: the ruins of the fourteenth-century Wardour Castle. Its story began in 1385, when Baron John Lovell acquired the land, and in 1392 King Richard II granted him permission to build a castle there. Wardour's six-sided design is unique in Britain and it is clearly inspired by the hexagonal castles that were in fashion at the time in parts of the Continent – especially in France. The Lovell family supported the Lancastrian cause during the Wars of the Roses, and as a result, the castle was confiscated in 1461 by the state and passed through several owners until bought by Sir Thomas Arundell of Lanherne in 1544. This ancient prominent Cornish family owned much land in Cornwall and held several estates in Wiltshire. However, just eight years later in 1552, Sir Thomas was executed for treason and the castle was again confiscated. In 1570 it was bought back by his son, Sir Matthew Arundell, and life returned to normal for the next seventy years. At this point, the 1st Baron Arundell of Wardour, Thomas Arundell, was a very active Catholic landowner and with the onset of the First English Civil

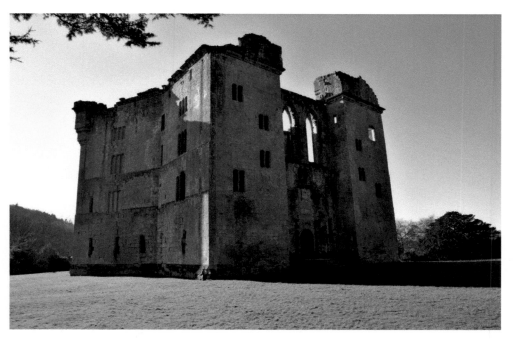

The fourteenth-century Old Wardour Castle. (Courtesy of Hugh Llewelyn CC BY-SA 2.0)

War, they naturally sided with the Royalists. During that war, the 2nd Baron Arundell of Wardour, also called Thomas, was away on the king's business leaving a garrison of twenty-five trained fighting men to defend the castle and his wife, Lady Blanche Arundell. On 2 May 1643 Sir Edward Hungerford arrived with a Parliamentarian army of approximately 1,300 men. With those inside refusing point blank to allow them in to search for Royalist sympathisers, Hungerford laid siege to the castle, using guns and mines on its walls. After holding out for five days, Lady Arundell agreed to surrender, with the castle being placed under the command of Colonel Edmund Ludlow. Lord Arundell died of his wounds after the Battle of Stratton that same month, so the son of Thomas and Blanche, Henry, 3rd Lord Arundell, brought a Royalist force to reclaim the castle. But this did not go exactly to plan. By November 1643 he had blockaded Wardour, but the excessive mining of the walls meant that most of the castle was blown up. The Parliamentary garrison did then surrender in March 1644, which was what he wanted, but sadly he had very little of his castle left to reclaim. In the coming centuries the family slowly recovered some of their power, but it wasn't until the 8th Baron that they were able to finance rebuilding. The result was New Wardour Castle, much more of a stately home than a castle, and the ruined shell of Wardour Old Castle remained as an ornamental feature. On the ground floor you can get a sense of some of the rooms that were once there, with the stairs that once led up to the great hall. Very little remains of the upper rooms, which once would have been the most inviting part of the castle. Like the great hall, they would have been high rooms with an intricate wooden roof. It is still possible to view the surrounding woodland estate from the top and this gives you an idea of the power this castle and family once had.

Chapter 6

Dorset

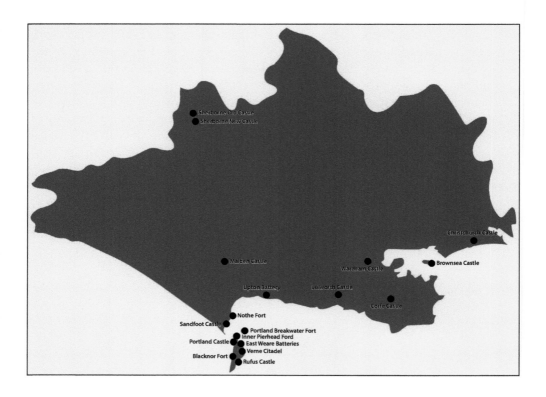

BLACKNOR FORT

Blacknor Battery, better known as Blacknor Fort, was constructed between 1900 and 1902 on a commanding clifftop location overlooking Lyme Bay, which allowed it to defend the western approaches to Portland. It had two gun emplacements, which were armed with 6-inch BL guns. Mounded with earth to provide protection, there was a command post, storerooms and magazines. The First World War saw the battery received an additional armament of two 15-pounder BL guns, positioned on either side of the battery, one 5-inch BL gun and three Bren guns. These were added to provide

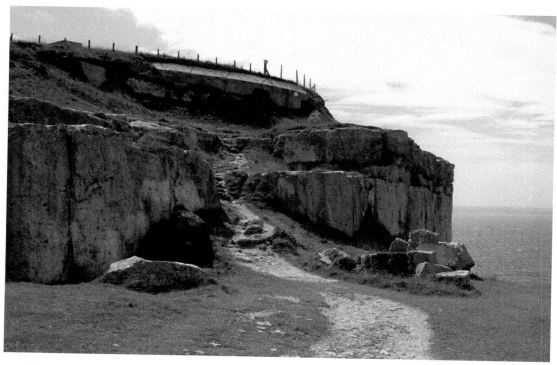

The approach to Blacknor Fort. (Courtesy of Tony Atkin CC BY-SA 2.0)

additional protection for Whitehead's Torpedo Works at Wyke Regis and the Royal Navy's Mere Oil Fuel Depot on the western side of Portland Harbour. During the Second World War the battery was manned by 103 Battery of 522 Coast Regiment, with a new observation point being built, along with blast walls and two anti-aircraft Bren guns. It was decommissioned by 1956 and is now private property, although the observation post from the Second World War and the two gun emplacements from the First World War remain accessible to the public and are located alongside the route of the South West Coastal Path.

BROWNSEA CASTLE

Also known as Branksea Castle, Brownsea Castle was built on Brownsea Island between 1545–47 in order to help protect Poole Harbour from a potential French attack. This one-storey square blockhouse was approximately 13 metres across and had the sea by the side of its hexagonal gun platform, and a moat around the other three sides – with access controlled by a 7-metre-long drawbridge. Paid for by the Crown and the town of Poole, there was a garrison of six men manning the eight artillery pieces. Coastal erosion was a constant threat, with repairs being carried out a number of times, as well as additional defensive walls being constructed. Still garrisoned in the seventeenth

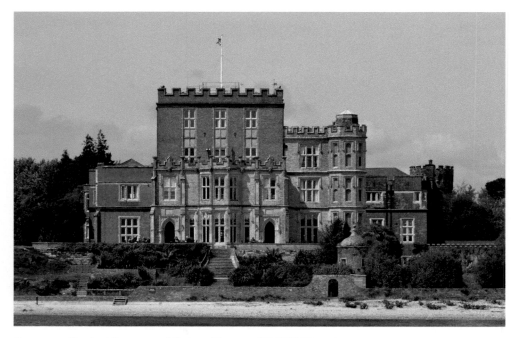

Brownsea Castle. (Courtesy of Robert Pittman CC BY-ND 2.0)

century, the English Civil War saw the castle held under the Parliamentarian Governor of Poole. 1644 saw the Parliamentarians refortify the site and send additional artillery pieces to the castle, which now had a garrison of twenty. In the years that followed the Civil War, the castle had outlived its usefulness and it gradually fell into disrepair. In 1726, the island was bought by architect William Benson, who sought to convert the blockhouse into a private residence, and so began 200 years of changing ownership and continual extensions to the castle and its surroundings – by 1901, the three-room original blockhouse was now a lavish thirty-eight-bedroom house. In the twentieth century, it fell into disrepair, before being gradually restored since the 1960s.

CHRISTCHURCH CASTLE

Located in the town of the same name, there has been a defensive structure on the site of Christchurch Castle since the 900s, when a wooden fort was constructed here by the Saxons. After the Norman Conquest of 1066, a ditch and bailey were added and by 1160 the wooden structures were replaced by stone ones. A large tower, or keep, was built around 1300, and it's two of these walls that remain today. During the English Civil War of 1642–51, the castle was taken by the Parliamentarians in 1644, and although the Royalists lay siege to it, it remained in their hands until the end of the war. In 1652, Oliver Cromwell ordered that the stronghold was to be slighted, and since then it has been in the ruined state that you can see today.

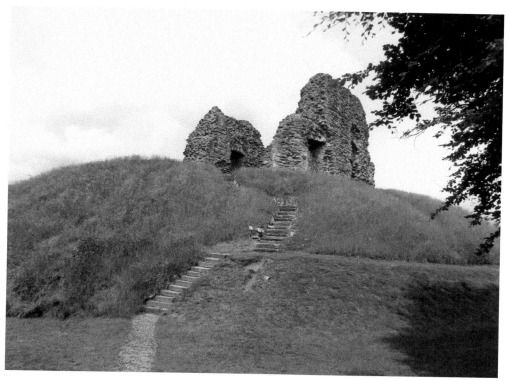

The ruined remains of Christchurch Castle. (Courtesy of Elliott Brown CC BY 2.0)

CORFE CASTLE

Arguably one of the most stunning castles in the country, Corfe Castle has a history that dates back over a thousand years. Corfe became a key part of William the Conqueror's efforts to cement his new power over the English in the aftermath of 1066 – with the castle mound being one of the first to get stone walls instead of wood. The keep was then completed in 1105 for King Henry I, the son of William the Conqueror, with the aim of being a mighty show of Norman power. Standing at 21 metres tall on top of a 55-metre-high hill, it can be seen for miles around. In the centuries that followed, inner and outer walls, towers and a multitude of buildings were added to the castle complex, and many political prisoners were locked up here. The height of the keep was increased, and it is believed that it may have been whitewashed in 1244, which would have certainly made it dominate the surrounding landscape even more! By the seventeenth century, the Royalist Bankes family owned the castle, and during the English Civil War, it survived two different sieges by the Parliamentarians – until it was eventually taken after one of the Royalist soldiers betrayed Lady Mary Bankes. The result was what we see today, as an Act of Parliament was passed at Wareham to destroy the castle. Deep holes were dug around the castle and packed with gunpowder, which brought the towers and walls crashing down and left the castle a ruin. Despite

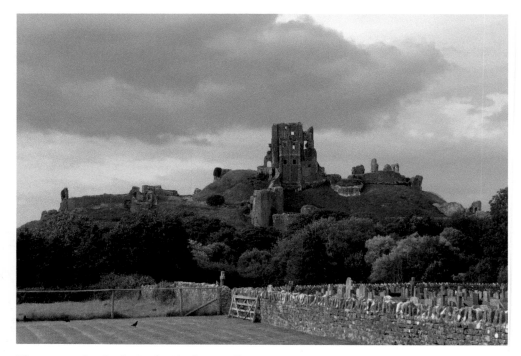

The spectacular Corfe Castle. (Author's collection)

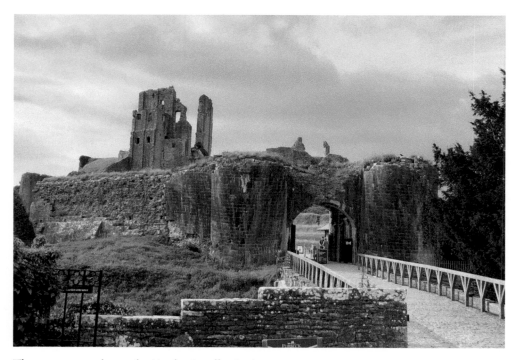

The entrance to the castle. (Author's collection)

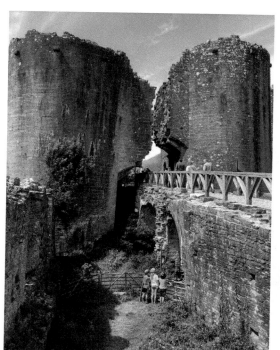 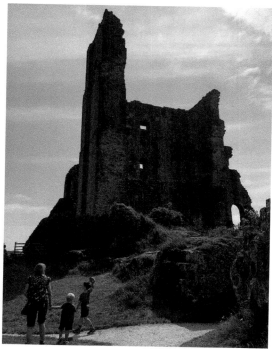

Above left: The destruction of the English Civil War is clearly seen on this gatehouse, as one side is significantly lower than the other. (Author's collection)

Above right: It is only when you are close to the keep that you realise its impressive size. (Author's collection)

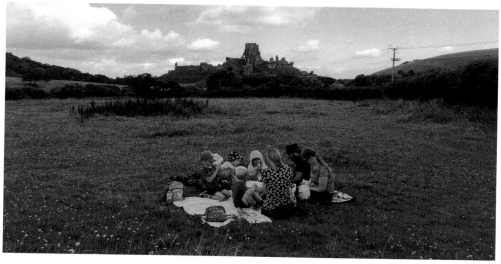

A family enjoy a picnic in the surrounding countryside, which is still dominated by the castle in the distance. (Author's collection)

this, Mary Bankes then petitioned Parliament for a number of years for the return of the castle estate. Incredibly, this worked, and Corfe Castle was handed back to her, with the Bankes family retaining possession until 1982, when Ralph Bankes gifted the castle to the National Trust.

EAST WEARE BATTERIES

In 1859, due to the rising tensions with France, earthen temporary batteries were established at East Weare, with work on the permanent batteries beginning in 1862. Built to protect Portland Harbour, plans were made for eight gun batteries to be installed, but due to issues with land stability and drainage, only five sections, known as A, B, C, D and E Batteries, were completed by 1870. By 1874, seven 10-inch RMLs and thirteen 9-inch RMLs had been installed and extensive alterations and additions were then carried out between 1875 and 1878 to modernise the batteries – due to the ever-increasing advancements in technology. At the turn of the twentieth century, the introduction of the superior BL gun led to A and B batteries being

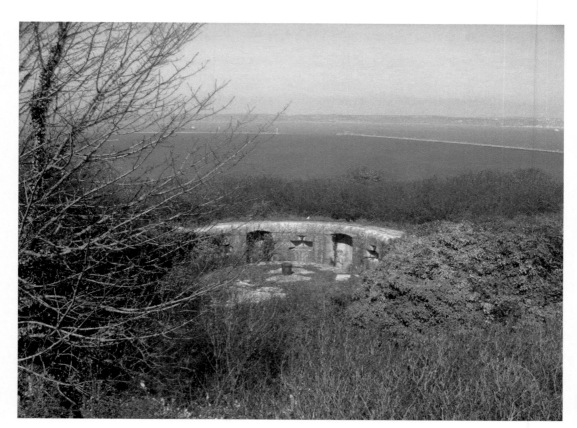

East Weare Gun Battery E. (Courtesy of AJ Smith CC BY-SA 3.0)

updated, with C to E batteries being abandoned. During the Second World War, the batteries were manned by personnel of 102 Battery, and a number of pillboxes were built across the site. The area was decommissioned in 1956. However, A and B batteries were still used by the Royal Navy as a DISTEX site, and was regularly used for disaster relief training right up until 1996. Today, the batteries remain closed to the public.

INNER PIERHEAD FORT, PORTLAND

Inner Pierhead Fort was one of a number of fortifications built to defend Portland Harbour in the nineteenth century. Constructed in 1862, it was 100 feet in diameter, and was armed with eight 64-pounder guns. A 40-mm Bofors gun was added during the Second World War but after the end of the conflict, it was no longer used. The fort can still be spotted on the inner breakwater.

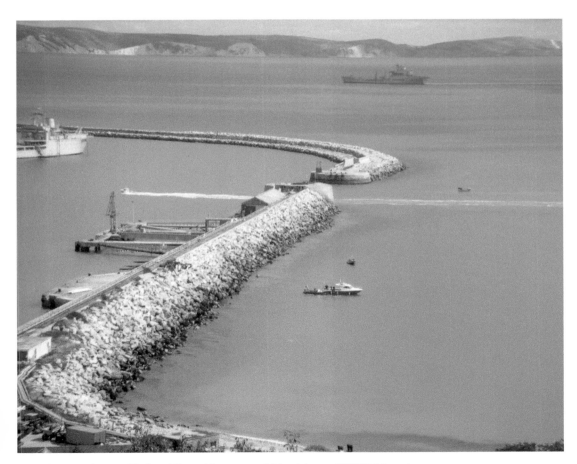

A view of Inner Pierhead Fort. (Courtesy of Ajsmith141 CC BY-SA 2.0)

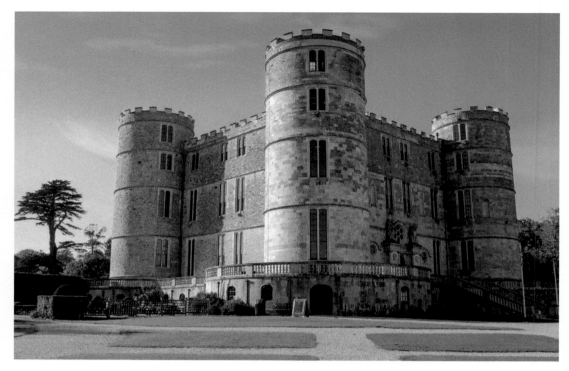

The Grade I listed Lulworth Castle. (Courtesy of Alison Day CC BY-ND 2.0)

LULWORTH CASTLE

Completed in 1609 to the south of the village of Wool, the Grade I listed Lulworth Castle is a hunting lodge built in the style of a fortified castle. During the English Civil War, the Roundheads took control of the property and used it as a rather grand garrison, and the French royal family were invited to use the estate as one of their residences-in-exile following the French Revolution. Fire gutted the castle in 1929, and it wasn't until the 1970s that restoration work began. Today, still owned by the Weld family, it is open to the public.

MAIDEN CASTLE

It is hard not to be impressed by Maiden Castle, which is one of the largest Iron Age hill forts in Europe, let alone in Britain! Located just to the south-west of Dorchester, it dominates the surrounding landscape, and in covering over 45 acres (the size of fifty football pitches) it is easy to see why. Archaeologists believe that when it was first built, its ramparts would have been covered in white chalk, making it a visually dominating sight. A single rampart was first constructed in around 600 BC and in 450 BC this was heightened, with additional ramparts and gateways being added.

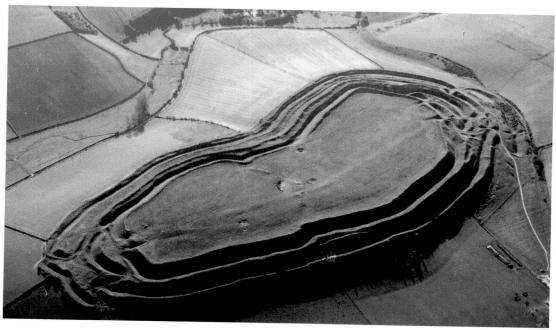

A stunning aerial view of Maiden Castle. (Courtesy of Andy Walker CC BY-ND 2.0)

Hundreds are thought to have lived here, and the series of defensive ditches and ramparts so carefully built to keep enemies at bay are still standing today. It is thought the castle was largely abandoned by the first century AD, but the foundations of a Romano-Britain temple dating from the fourth century AD have subsequently been found on the site.

NOTHE FORT

Nothe Fort, just to the east of Weymouth, occupies a stunning location on Dorset's Jurassic Coast. Construction started in 1860 by 26 Company of the Royal Engineers in order to protect Portland and Weymouth harbours. The three levelled D-shaped fort was fully commissioned in 1872, with No. 2 Battery Royal Artillery being the first soldiers garrisoned there. The magazines were dug well into the peninsula to protect the ammunition that was stored there, and the ground level casemates were designed to be bomb proof, housing as they did the accommodation and the heavy-loaded cannons. Above this, the ramparts provided a position to fire muskets and muzzle-loaded cannons. Initially armed with two 64 pounders, four 9-inch muzzle loaders and six 10-inch cannons, the development of weaponry saw the installation of three 6-inch Mark VII naval guns, which needed hoists to be installed to lift the 100-pound shells. However, it wasn't until the Second World War that the fort fired its guns in anger. Used as a central anti-aircraft ammunition depot for the south-west, it

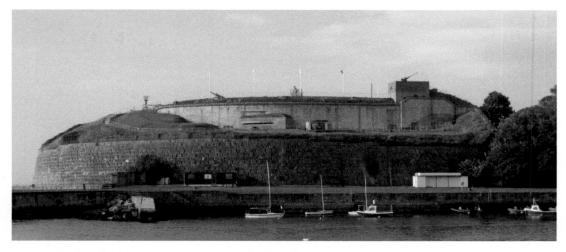

Nothe Fort, built in 1872 to protect Portland Harbour. (Courtesy of Jim Linwood CC BY 2.0)

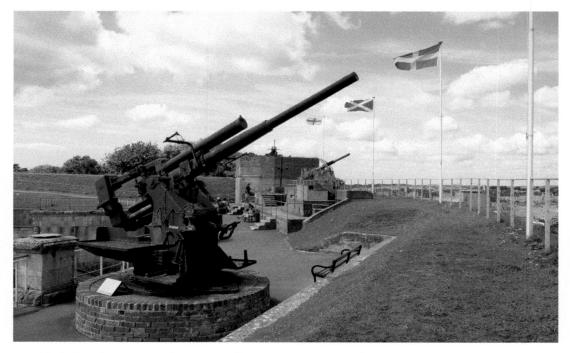

Nothe Fort has a range of weapons still in situ. (Courtesy of Chris Sampson CC BY-SA 2.0)

had an additional platform constructed to hold four Vickers QF 3.7-inch anti-aircraft guns, which were in regular action, particularly during 1940 and 1941.

In 1956 the fort was abandoned, and although the local council purchased it in 1961, it remained derelict, with numerous plans for its use, including that of becoming

a luxury hotel complex, falling through. In 1974 it became a Grade II listed building, but it wasn't until the 1980s that some restoration work began. During this time, some of the forts below ground magazine level was used as a nuclear shelter for civil administration as a result of tensions from the Cold War. It is now a museum, and arguably, one of the best preserved and maintained forts of its kind in the entire country. Original cannons and guns, along with a whole host of Second World War memorabilia and vehicles, are on display, and it is possible to spend hours exploring the depths of the fort's rooms and corridors.

PORTLAND BREAKWATER FORT

First planned in 1859 by the Royal Engineers, Portland Breakwater Fort was finally completed between 1868 and 1875 on the outer breakwater of Portland Harbour. This was no mean feat in those days, and a 61 metre diameter ring of stone needed to be laid on the seabed, followed by a granite base, to allow for subsidence. There were ports for fourteen heavy guns, with ammunition magazines and engine rooms below, and in 1892 it had seven 12.5-inch cannons. The walls themselves are 20 inches thick, and there would have been around thirty men stationed here at any one time. The First World War saw two 6-inch BL Mark VII guns positioned here, and in the Second World War, the fort was used as an examination battery. Abandoned in 1956, it still stands derelict today.

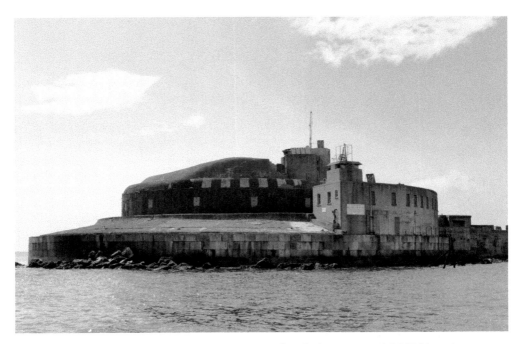

The derelict Portland Breakwater Fort. (Courtesy of Nicholas Mutton CC BY-SA 2.0)

PORTLAND CASTLE

Built between 1539 and 1541, Portland Castle was constructed on the Isle of Portland by King Henry VIII to defend the Portland Roads anchorage from potential French attacks. The original garrison was small, with four gunners and two other men, but by 1548, thirteen men were permanently stationed here with a range of artillery pieces. The fan-shaped castle was built from Portland stone and had a 37-metre curved central tower and gun battery, as well as two wings for artillery. Like most fortifications of this time, the landward facing side was defended by a moated earthwork, which was over 10 metres wide. During the English Civil War of the 1640s, the castle was taken by Royalist supporters, and it was only after two sieges that it eventually surrendered to Parliament. The castle saw further action in the First Anglo-Dutch War of 1653 during a three-day battle out to sea. At the end of the Napoleonic Wars in 1815 it was converted into a private house until 1869, when the War Office took it back and used it as soldier accommodation for more modern defences in the area, such as Verne Citadel. In the First and Second World Wars, the castle remained in use for accommodation and offices, as well as becoming an ordnance store, with 1949 being the end of its military life. Today, it stands in very good condition and is open to the public.

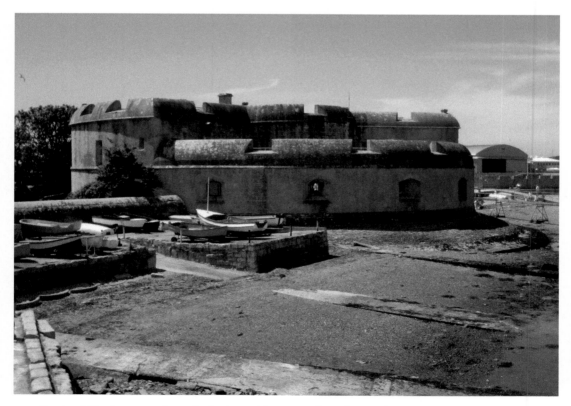

Portland Castle as seen from the harbour. (Courtesy of Mark Murphy CC BY-SA 3.0)

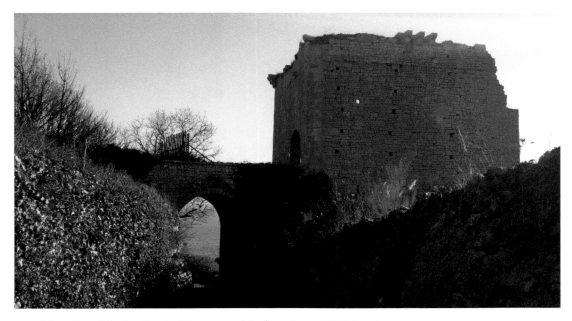

The ruins of Rufus Castle. (Courtesy of Andrew Bone CC BY 2.0)

RUFUS CASTLE

Sat on a clifftop overlooking Church Ope Cove on Portland, the original castle on this site was built for King William II, the third son of William the Conqueror, sometime between 1087 and 1100. He was known as William Rufus, meaning William 'the red', and this is where the castle gets its name. Captured in 1142 by Robert, Earl of Gloucester, and then upgraded in 1238 by Richard de Clare, the castle was completely rebuilt between 1432 and 1460 by Richard, Duke of York, and what remains today is largely from this period. Although suffering from erosion and collapse over the years, a large section of the keep remains, along with sections of the 2-metre-think walls, gun ports and a bridge, thanks in part to some extensive restoration work in 2010.

SANDSFOOT CASTLE

The Grade II listed Sandsfoot Castle, also sometimes known as Weymouth Castle, is one of the best surviving sixteenth-century artillery blockhouses in England. Built on cliffs to protect the Weymouth Bay anchorage in 1541, it would have worked in tandem with Portland Castle on the opposite side of the waterway, bombarding enemy ships with a battery of heavy artillery. The two-storey blockhouse had an octagonal gun room that contained five-gun embrasures, along with a flat roof, which likely had additional artillery on it. As early as 1583, repairs were required due to coastal erosion and despite these efforts, by 1623, a corner of the gun platform was starting

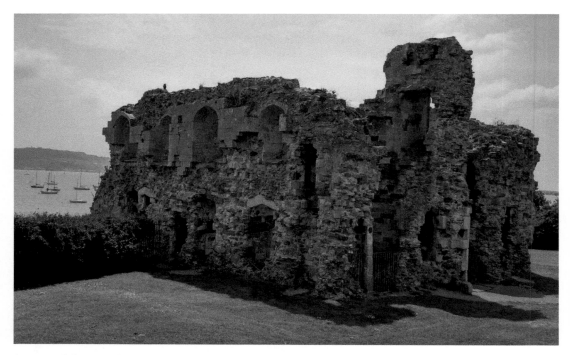

Sandsfoot Castle. (Courtesy of Andrew Bone CC BY 2.0)

to get undermined by the sea. During the English Civil War, the castle swapped hands between the Parliamentarians and the Royalists a few times, and in the aftermath it was withdrawn from military use in 1665 and only avoided being demolished by being used as a storehouse until the end of the seventeenth century. However, by 1725 it was in ruins, with some of the castle stone being reused by the town of Weymouth to build the new town bridge and some houses, and the gun platform gradually collapsing into the sea. By the 1930s, the ruins were closed to the public on safety grounds, but during the Second World War, an anti-aircraft battery was located here as part of the Portland Harbour defences. It then lay empty until substantial repair work was carried out for three years, reopening to the public in 2012.

SHERBORNE OLD CASTLE

Built between 1122 and 1137 by Roger of Caen, the Bishop of Salisbury, in order to protect the church estates in the area, it is easy to see why this location was chosen. The small hill on which the castle stands, together with the nearby lake, makes for a perfect defensive position. Despite this, the castle was taken by Robert, Earl of Gloucester, during The Anarchy in the early 1140s. In the centuries that followed, ownership of the castle passed between the church and the Crown. In 1592, Queen Elizabeth I leased the Sherborne estate to Sir Walter Raleigh, who decided against

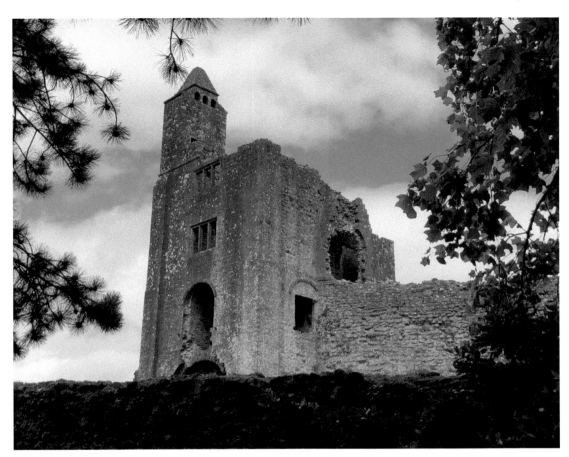

Sherborne Old Castle. (Author's collection)

refurbishing the existing castle in preference for constructing a new house nearby, which was known as Sherborne Lodge.

The original castle structure was captured in the English Civil War by the Parliamentarians in 1642, before being recaptured by the Royalists in 1643. In August 1645, the New Model Army lay siege to the castle with heavy bombardment and mining, and following the Royalist garrison surrender, it was slighted, with the ruins still standing today.

SHERBORNE NEW CASTLE

Completed in 1594, this four-storey symmetrical brick structure had four corner turrets and was often used as a summer-time retreat. When Raleigh was imprisoned in the Tower of London by King James, the estate was re-leased to Robert Carr, who then sold it to staunch Royalist Sir John Digby, 1st Earl of Bristol, in 1617. He

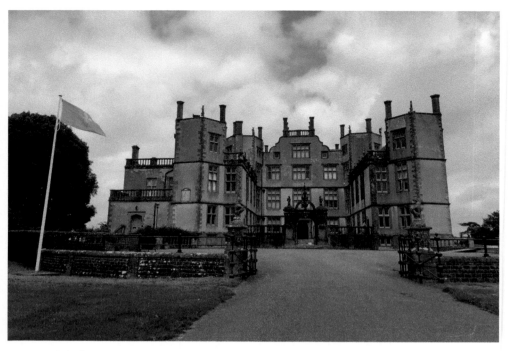

A view of Sherborne New Castle. (Courtesy of James Powell-Thomas)

The Solarium of Sherborne New Castle. (Courtesy of the Wingfield-Digby estate)

promptly added four new wings to the building, and when the Civil War erupted in the 1640s this mansion was left largely unharmed, unlike the original castle. In 1753, renowned landscape architect Capability Brown redesigned the surrounding area, so the ruins of the old castle became part of the gardens. In 1856, the estate passed to the Wingfield-Digby family, who still own it today, and architect Philip Charles Hardwick modernised the house. The First World War saw the Red Cross use the house as a hospital, and in the Second World War it became the headquarters for commandos involved in the D-Day landings.

UPTON BATTERY

Upton Battery, also known as Upton Fort, was constructed between 1901 and 1903 to the north-east of Portland Harbour with two 6-inch BL guns in its western emplacements and two 9.2-inch BL guns in the eastern ones. During the First World War, the 9.2-inch guns were bolstered by three Maxim guns, along with some additional observation posts and storage buildings. The battery was fully operational during the Second World War, with the gun emplacements being modified to take two 6-inch BL Mark XVI guns, which had once been fitted on the battleship HMS *Erin* and manned by 522 Dorsetshire Coastal Regiment. Additional defences and weaponry including a QF 4.5-inch howitzer, 40-mm Bofors gun, anti-personnel mines, spigot mortars and machine guns were installed, and on the sloping hillside overlooking Weymouth Bay, two searchlight emplacements and a machine gun post were constructed. Upton Battery was decommissioned in 1956 and is now on private land.

VERNE CITADEL

As an artificial breakwater was installed to make Portland Harbour bigger and therefore more important to shipping, so the need for new defences to protect it became evident. The result was Verne Citadel. Sat on the highest point of Portland, it was built between 1857 and 1881 and held a commanding position overlooking the harbour. Designed with large open gun emplacements on its north, east and western sides, it covered a large swathe of land and had five open batteries, recorded in this publication as a separate entry under East Weare Batteries. One of special mention is the Verne High Angle Battery, which was built within a disused quarry on the site, which meant the guns were hidden from enemy view. The citadel was inaccessible from two sides and the south and west approaches were defended with a large ditch. During the First and Second World Wars, the citadel became the headquarters of the Coastal Artillery, and a Chain Home Low Radar set was installed on the site. The main magazine was turned into a military hospital, and anti-aircraft guns were installed. In 1949, with its military life at an end, the citadel was turned into a prison and that is still its role today.

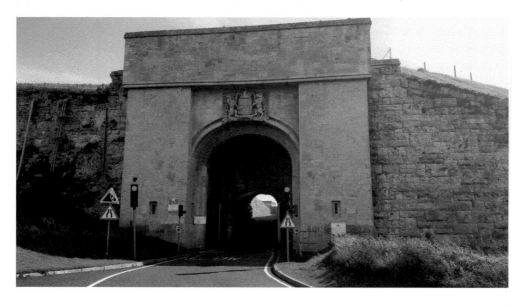

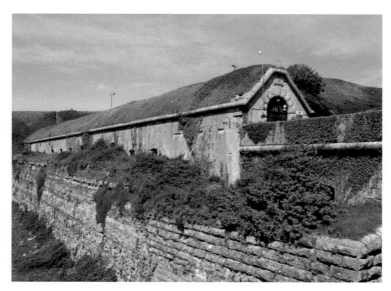

Above: Verne Citadel – now the entrance to HMP The Verne. (Courtesy of Andrew Bone CC BY 2.0)

Left: A view of the outside of Verne Citadel. (Courtesy of Jim Linwood CC BY 2.0)

WAREHAM CASTLE

There's not much to see of Wareham Castle now. In the late eleventh and early twelfth century, a stone motte-and-bailey castle was built at the location, as there were already Anglo-Saxon earthen ramparts and the River Frome providing a good defensive position. The castle is known to have been standing in the Civil War of 1135–54, but after that it quickly fell into disrepair and its stone was no doubt taken and used for other building projects in the area.

Acknowledgements

What a fascinating book this has been to research. Exploring a great swathe of the country, one that includes the area I grew up and spent my childhood exploring, as well as the county I now call home, has been an exhilarating and time-consuming process. It has allowed me to rediscover locations, buildings and ruins, in addition to uncovering new sights, sounds and stories. Best of all, I have been able to do it with my family and friends in tow. Seeing the excitement on the young children's faces as a vast keep comes into view or hearing the thrill in their voice as they spot a centuries-old cannon reminds me of just how captivating these structures can be. And they still enthral young and old today.

In this day and age it is possible to do a lot of research online, but nothing compares to actually heading out and exploring things for yourself. Only when you see the history in its original environment does it start to make sense. Investigating the different aspects of this book has led me to find out some incredible things and meet a number of wonderful people, all of whom have been willing to share their knowledge and expertise, and this is so important in passing on the history of our communities to the next generation.

However, this book has not been without its challenges. Creating an overview of so many structures that cover such a large area has meant seriously condensing the illustrious history of many into just a few hundred words.

I need to express my gratitude to the many organisations, people and photographers who have kindly shared their knowledge and allowed me to use their photographic work in my book, with a special mention to Maria Wingfield-Digby at Sherborne New Castle in Dorset.

I would also like to thank Nick Grant, Nikki Embery, Jenny Bennett, Becky Cadenhead and all at Amberley Publishing for their help in making this project become a reality, as well as my parents, friends, wife Laura and sons James and Ryan, who accompanied me on many wonderful trips across the length and breadth of the West Country.

About the Author

Andrew Powell-Thomas writes military history, local heritage and children's fiction books. He regularly speaks at events, libraries, schools and literary festivals across the South West, as well as making appearances on television and radio. Andrew lives in Somerset with his wife and two sons. It is possible to keep up with everything he is up to by following him on social media or by visiting his website at www.andrewpowell-thomas.co.uk.

Andrew's other titles available with Amberley Publishing:

The West Country's Last Line of Defence: Taunton Stop Line
Historic England: Somerset
50 Gems of Jersey
50 Gems of Somerset
50 Gems of Wiltshire
50 Gems of the Isle of Wight
Cornwall's Military Heritage
Devon's Military Heritage
Somerset's Military Heritage
Wiltshire's Military Heritage
The Isle of Wight's Military Heritage
The Channel Islands' Military Heritage